IMAGES
of America

LOGGING IN THE
CENTRAL SIERRA

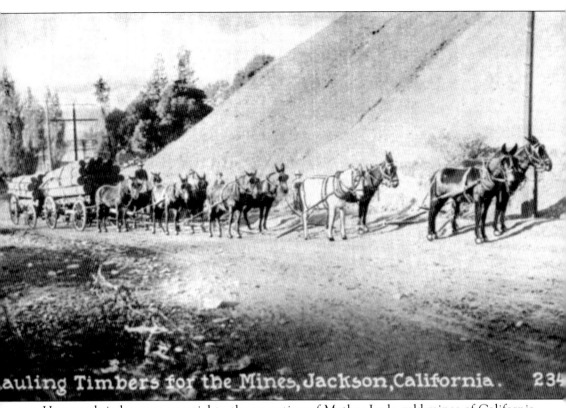

Harvested timber was essential to the operation of Mother Lode gold mines of California. (Courtesy Ross Oliveto.)

ON THE COVER: This steam rail logging operation was located in the higher elevations of Amador County. It utilized oxen, a narrow-gauge railroad, and a flume and employed over 50 men seasonally. A more detailed description is on page 57. (Courtesy Amador County Archives.)

IMAGES of America
LOGGING IN THE CENTRAL SIERRA

Carolyn Fregulia

Carolyn Fregulia

ARCADIA
PUBLISHING

Copyright © 2008 by Carolyn Fregulia
ISBN 978-0-7385-5816-5

Published by Arcadia Publishing
Charleston SC, Chicago IL, Portsmouth NH, San Francisco CA

Printed in the United States of America

Library of Congress Catalog Card Number: 2007940256

For all general information contact Arcadia Publishing at:
Telephone 843-853-2070
Fax 843-853-0044
E-mail sales@arcadiapublishing.com
For customer service and orders:
Toll-Free 1-888-313-2665

Visit us on the Internet at www.arcadiapublishing.com

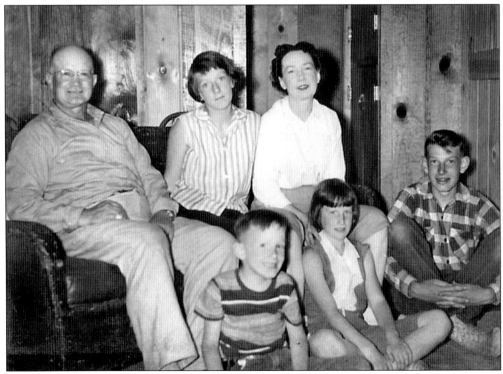

This book is dedicated to Ben and Etta Berry and their children. Pictured below are Ben, Lynna, Etta, John, Marla, and Ben Jr. in 1958. (Courtesy Ben Berry collection.)

CONTENTS

Acknowledgments		6
Introduction		7
1.	Euro-Americans Come to the Central Sierra	9
2.	The Early Years of Logging	31
3.	Early Transportation	43
4.	Twentieth-Century Advances	63
5.	Logging Trucks	85
6.	The Berry Lumber Company	101
Bibliography		127

ACKNOWLEDGMENTS

Ben Berry, his wife, Etta Ryan Berry, and their children are truly the inspiration for this book. Working with Ben Jr., Lynna, Marla, and John has been a wonderful experience. Other family members also contributed, including Ruthie Bosse Hobbs and Diane Adams Aksland. Special thanks goes out to Bill Braun, Jim Laughton, Claude Tremelling, Sheldon Johnson, and Joe and Tico Arnese, who lent their formidable knowledge of the logging industry to the writing of this book. Eric Costa and my husband, Ed McCracken, were wonderful editors. Deborah Cook of the Amador County Archives and Ellen Martin of the Alpine County Museum and Douglas County Historical Society provided a great deal of help with this project. I also want to thank Fred Thomas, the Oneto family, the Babe Garbarini family, Jim Laughton, Ross Oliveto, the Dickerman/Dondero family, the Kennedy Mine Foundation, and, of course, the Berry family, for their generous photograph contributions.

INTRODUCTION

Logging has been prevalent in the Central Sierra since the California Gold Rush when European Americans first settled in the foothills. Harvested timber and milled lumber were essential to mining and the construction of early-day communities. When hard rock mining emerged as the leading industry in the Mother Lode during the following decades, the nearby forestlands were logged extensively. Meanwhile, the Comstock Lode in Nevada created a tremendous demand for timber that resulted in the denuding of much of the eastern slope. Logging developed into one of the major industries in the region during the 20th century. It was not until recently that timber harvesting has been curtailed, due in large part to economic factors and to our environmentally conscious society.

 The spectacular Sierra Nevada, a 430-mile mountain range, forms the backbone of California. With its high mountain passes and rugged terrain, it was a formidable fortress that few dared to traverse before 1840. Indeed, had it not been for gold discovery, the Sierra may have been left untouched for decades. But the Euro-Americans came, they settled, and they exploited. Their impact was far-reaching and permanent.

 Today we venture into the high country and we marvel at its beauty. But in truth, the forests have changed. The majestic old growth is gone. In its place is a younger generation of foliage. It is dense, littered, and composed of varying species that strangle and suffocate. Fir now dominates areas once forested with yellow (Jeffrey) and sugar pine. The forest of today is vulnerable, unhealthy, and dangerous. Curtailed logging, coupled with policies of fire prevention and intense reforestation, has created a region containing more foliage than the prehistoric forests and, as such, a forest prone to devastating, high-intensity fires.

 The prehistoric Sierra Nevada forest is defined as existing prior to Euro-American intrusion. It extended unbroken from the California foothills to the bald peaks at the crest and down the east slope into the Great Basin of Nevada. The vegetation in these ancient forests was not dense. Frequent, low-intensity surface fires removed most litter, brush, and dead and dying trees. With more access to sunlight and less competition from other vegetation, the surviving trees grew taller and were healthier overall. Typically tree crowns were relatively open. They grew in irregular patches with single trees scattered about the mountainsides. Undergrowth consisted of herbaceous plants and low-density shrubs. Aspen, willow, and other deciduous trees and shrubs were often in the early stages of growth because of recent fires. These fires thinned the forest, prevented widespread establishment of new trees, and promoted the growth of grasses, wildflowers and sprouting shrubs and trees.

 John Muir wrote, "The inviting openness of Sierra woods is one of their most distinguishing characteristics. The trees of all of the species stand more or less apart in groves, or in small irregular groups, enabling one to find a way nearly everywhere, along sunny colonnades and through openings that have a smooth, park-like surface." Today this description of the openness of the Sierra forests rarely holds true.

Although lightning caused most Sierra fires, many were intentionally ignited by the Native Americans. The Sierra Nevada was occupied almost solely by Native Americans prior to 1848. For more than 12,000 years, they made deliberate and successful attempts to control forest vegetation by using fire. Several reasons have been identified as to why the indigenous population burned the forests. With fire, they could manipulate oak and acorn resources and enhance the growth of other food plants. Cleared meadows improved hunting, and the removal of brush and new growth allowed for easy communication and unimpeded travel.

Prior to the California gold discovery, no one was interested in settling in the foothills (except the Native Americans). The Californios who populated the coastal region and the Central Valley saw the foothills as hot, brush-covered, and having little agricultural value. Only timber stands found in the lower elevations held any attraction for the pre–Gold Rush Euro-American settlers, who quickly harvested them, then left. Despite the two centuries of European involvement along the Pacific slope, the native inhabitants of the Sierra foothills and high country remained relatively safe from outside interference.

The effect of the Gold Rush on the indigenous population was first felt in the mining region of the Sierra foothills, where they were displaced by the miners and where food resources were greatly reduced. Disease spread beyond the areas of direct contact, bringing catastrophic population reductions throughout the Sierra Nevada. It is estimated that nearly 100,000, or one-third, of Native Californians died as a result of disease, starvation, and violence between 1848 and 1855. Within years, the Native American fire-management practices that shaped the prehistoric forests ended permanently.

The gold discovery and resulting settlement of Euro-Americans in the Sierra Nevada profoundly changed the region. Areas were stripped of vegetation in the mining process or to provide for grazing. The demand for timber, lumber, and cordwood led to the denuding of mountainsides and ravines. The resulting floods eroded much of the topsoil. As settlement advanced into the higher elevations, permanent transportation routes were established and remote areas became accessible.

Logging over the past 150 years has removed much of the old-growth forest. What remains is either protected in preserves or is located in inaccessible areas. However, many second-growth stands have trees that thrived when the mature forest was removed and are now as large as the old-growth trees. These younger stands are overcrowded. Rather than clearing the forest as some feared, logging actually contributed to this rapid growth and the resulting forest density.

The clear-cutting of the 1980s gave rise to an environmental and political movement against all logging in the region. Today public opinion holds that the forests were historically harvested and abused at the expense of wildlife, aesthetics, and recreational values. Some environmental groups denounce man's intervention of forested land, suggesting that only nature be allowed to manage it. Some advocate there be no suppression of lightning-caused fires, minimal public access, and absolutely no timber harvesting.

The U.S. Forest Service, nevertheless, has endorsed the concept of "ecosystem management" to better protect and care for the long-term health of the timberlands. This concept involves the nurturing of forests as a whole, which includes well-managed logging practices, prescribed burns to reduce fuels, and restricted motorized access to sensitive areas. It is hoped that a forest condition will develop that maintains the health of vegetation and wildlife habitat, reduces the danger of destructive fires, and provides economic opportunities for forest-dependent communities. The forest service, however, no longer manages federal lands for sustained timber yields.

Logging in the Central Sierra persisted for over 150 years as an industry essential to the California economy. These pages contain the history of its development, expansion, technological advances, and how this industry touched the lives of many over the decades. Although the sequoia redwoods are also found in this region, this book focuses primarily on the pine forest.

One

Euro-Americans Come to the Central Sierra

Euro-Americans did not inhabit the interior regions of California until the early 1820s. Few traveled over the rugged Sierra Nevada, preferring to navigate the seas or circumvent the fortress from either the south or the north. It was not until 1827 and then again in 1833 that any recorded crossings were made. Beginning in 1840, however, an increasing number of Euro-Americans migrated to California through the Sierra. These travelers did not remain in the high country or foothills for any length of time. Their destination was the coastal region or the Central Valley.

Aside from some harvesting of timber, there was little Euro-American involvement in the western foothills. Then, on that fateful day in January 1848, James Marshall discovered gold at Sutter's Mill in Coloma. Within months, the foothills were bombarded by gold seekers. They immediately began exploiting the Sierra's most bountiful asset, its forests.

By the late 1850s, most of the "easy" placer gold was gone. Extracting the precious metal became expensive, requiring timber to support excavations and tunnels, milled lumber for construction of flumes and mine workings, and cordwood to fuel steam engines and pumps. The lumber used to construct early mining towns had become tinder dry. These towns would soon fall victim to devastating fires, and additional lumber would be needed for reconstruction. Within a few years, the Mother Lode was stripped of its oak woodlands and pine forests.

Meanwhile, the miners ventured eastward in search of gold but instead found silver. In the "rush" of the Nevada Comstock, the Tahoe Basin and east slope of the Sierra was denuded. Over one-quarter of the prehistoric forest was gone.

The detrimental impact of this early exploitation forced governmental intervention beginning in the 1860s. As time went on, more and more timberland came under government jurisdiction. Logging became regulated, fire prevention became policy, and those areas destroyed by logging or fire were replanted. The forest that returned was forever changed.

The prehistoric forests of the Sierra Nevada were less dense than they are today. Frequent low-surface fires removed brush, litter, and dead foliage, creating a forest of taller, healthier trees (above). These fires were sometimes caused by summer lightning storms as depicted below. Others were deliberately set by the indigenous population, who depended upon acorns and pine nuts for their sustenance. They hunted the forest for game, fished its icy waters, and lived beneath its crown of trees. Fire helped the Native Americans to manipulate their food sources and keep the forest floor clear. Perhaps they also recognized the danger that a high-intensity fire caused as it swept through the mountains. By periodically starting low-surface burns, the Native Americans protected their home and environment. (Above, courtesy Ross Oliveto; below, courtesy Alpine County Museum.)

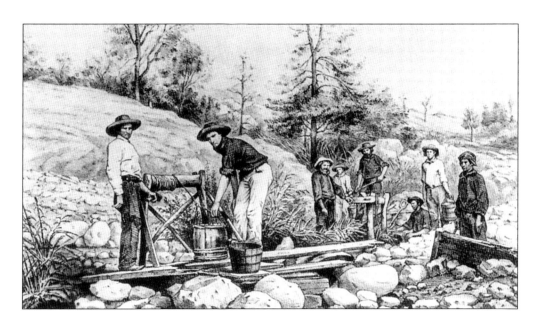

Although Euro-Americans had no permanent settlements in the Sierra Nevada prior to the Gold Rush, timber was harvested in the foothills. In 1847, John Sutter constructed a sawmill on the South Fork of the American River. The following January, James Marshall noticed gold flakes in the tailrace. The California Gold Rush thus began. Tens of thousands poured into the foothills, bringing axes and whipsaws, the tools needed to construct sluice boxes and flumes. The above depiction of the early miners shows the makeshift equipment they used. Tent cities appeared overnight along rivers and streams. The transient prospectors felt little need to construct anything more permanent. But with that first cold, wet winter of 1848–1849, log cabins began appearing in the region. They were quickly built on-site as suitable logs could be found everywhere (below). (Courtesy Ross Oliveto.)

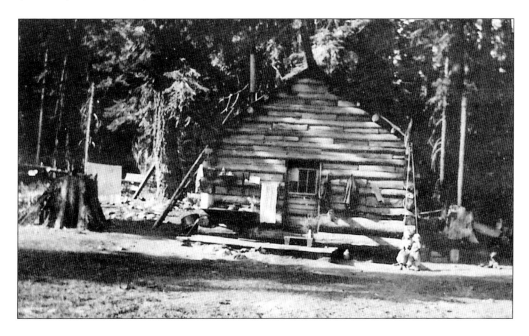

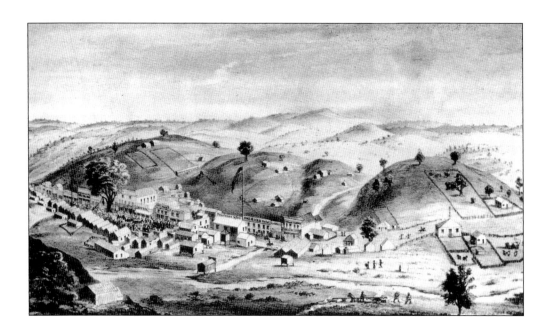

The miners soon began building permanent structures. The mining camp of Jackson was situated at the convergence of three placer-rich streams. By August 1850, seven buildings had been constructed. However, fall brought a great immigration of miners into the settlement. More structures were hastily erected so that by December, over 100 buildings stood. Small sawmills were quickly established to meet the demand, and the most readily available timber was immediately harvested. In the above depiction of Jackson in 1859, except for a few oaks, there were very few trees left standing on the hillsides surrounding the town. Below, Double Springs was the site of the first courthouse in Calaveras County. A perfect example of early construction, most buildings became tinder dry and burned in the 1860s. (Courtesy Ross Oliveto.)

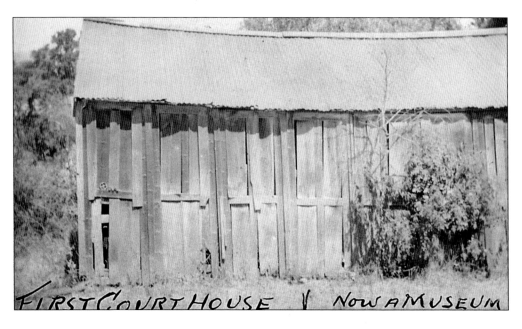

The tall, straight sugar pine was preferred by the miners because it provided high-quality, easily milled white lumber. J. D. Mason, in his *History of Amador County, California*, wrote in 1881, "A cluster of fair-sized pines once stood on the south side of Jackson creek, where it runs through the green ledge. These were all cut down and hauled to Lancha Plana some 20 years since for bridge timbers. Between Ione and Jackson scarcely a pine can be seen, and around the latter place they are by no means plenty. A few, far up the side of Butte Mountain, have escaped the slaughtering axe of the lumberman. One sugar pine, too crabbed and crooked for shakes, still holds its long arms to the breeze, the only specimen to be seen for miles around. At Pine Grove enough are left to give a plausible reason for the name of the town. Practically, the timber is cut away for a distance of 35 miles from the foothills, the little that is left within that distance being in inaccessible places." (Courtesy Fregulia collection.)

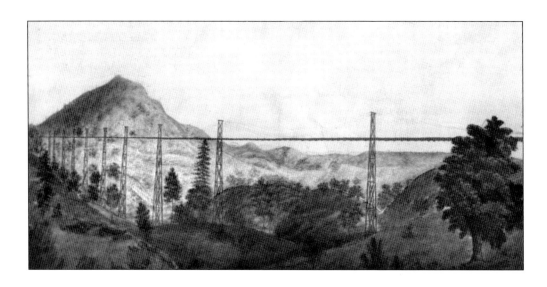

By 1851, the gold seekers had become familiar with California's climate of cold, wet winters and hot, dry summers. They realized that rich placers existed in the gravels of ancient river systems capping the ridges. But without water, successful mining of these regions was impossible. Looking toward the year-round flows of creeks and rivers, prospectors soon built ditches, flumes, and aqueducts to transport water from one location to another. Suspension flumes, such as the 3,300-foot-long Tunnel Hill Flume near Butte Mountain, were fairly common. This flume, pictured above in the Joseph Lamson painting, was built in the summer of 1858 by the Butte Canal Company. A heavy windstorm demolished it in November 1863. Below is a flume constructed to bring water to a hydraulic mining operation. (Courtesy Amador County Archives.)

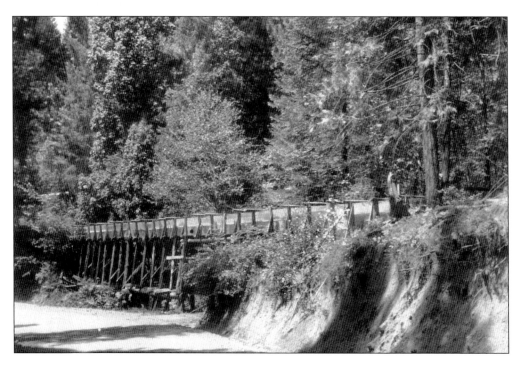

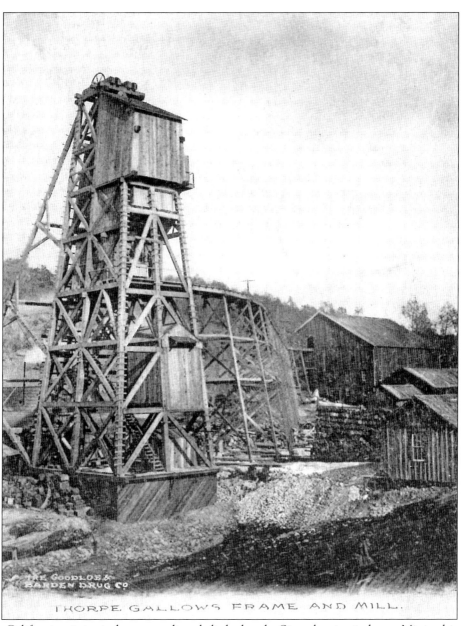

The California mining industry was directly linked to the Sierra logging industry. Mining history can be divided into three chronological periods. Between 1848 and 1851, placer gold deposits were exploited primarily by amateurs with few skills employing simple technology. Wood was needed to build makeshift flumes and small cabins and for fuel. During the second period, between 1851 and 1859, most of the surface mineral deposits were exhausted and gold exploration turned to riverbeds, quartz veins, and alluvial gravels. Mining required more capital, new techniques, and large supplies of milled lumber for canals and flumes. Finally, between 1860 and 1890, mining became a capital-intensive industry requiring a labor force employed in deep quartz mines. The demand for timber was insatiable, robbing the Sierra of much of its prehistoric growth. Above, the Thorpe Gallows Frame and Mill of Angels Camp, Calaveras County, demonstrates the amount of lumber needed for construction. (Courtesy Fregulia collection.)

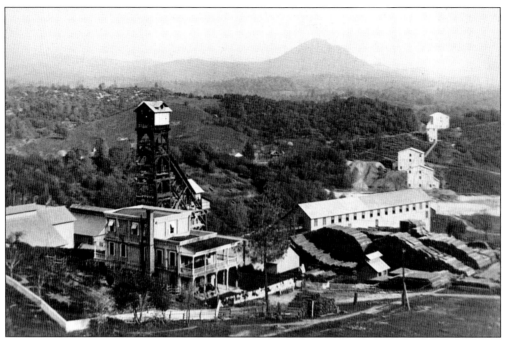

The construction of the East Shaft of the Kennedy Mine in Jackson, Amador County, in 1900 used an enormous amount of timber and milled lumber. Pictured above are the wooden headframe, mine office, hoist, machine shop, sawmill, and stamp mill. In the background are four buildings that enclosed the tailing wheels. The log deck held timbers used to reinforce the shaft. Pictured below is a close-up of the log deck. Debarked logs have been bucked to length. The squared timber was cut from the heartwood of the log. Also yarded are vast amounts of milled lumber used below ground. (Courtesy Kennedy Mine collection.)

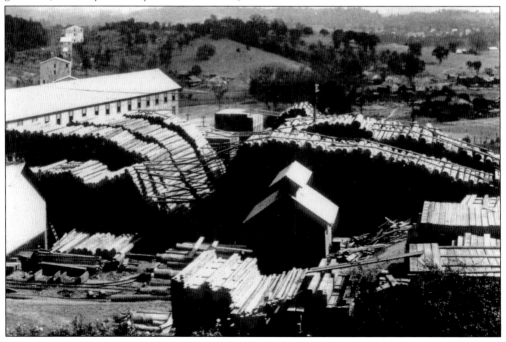

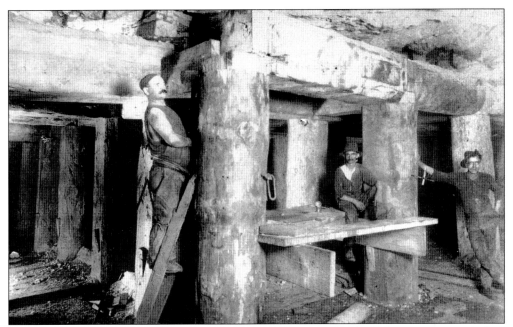

Square-set timbers were used below the surface to shore up the shaft. Lumber lagging bolted to support beams prevented loose rock from falling from the roof. Because of dampness, heat, earth movement, and sheer weight, the shafts were re-timbered frequently. This photograph taken below ground at the Argonaut Mine demonstrates the incredible amount of wood used. (Courtesy Jim Laughton.)

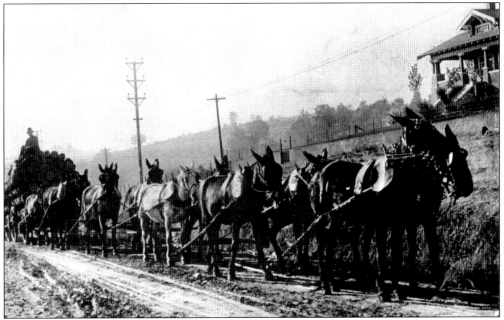

The logs were usually delivered to the mines by private teamsters. Above, Dave Oneto is shown here hauling small-diameter logs up Jackson Grade to the Argonaut Mine using a 12-mule team. These logs were harvested at Buckhorn, Amador County. It took two days to reach Jackson. Oneto was paid $4.50 per day. (Courtesy Oneto family.)

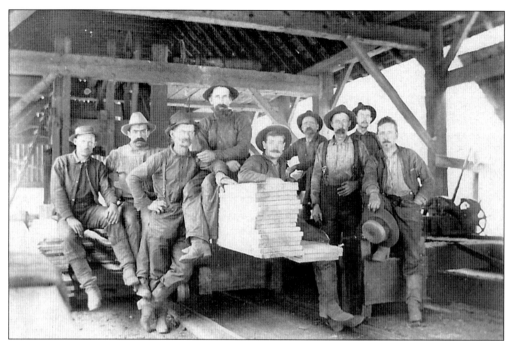

Most of the mines had their own sawmills, similar to that of the Kennedy pictured here. Timbers were milled into dimensional rough-cut lumber to be used below the surface. The length of the lumber, squared timbers, and debarked logs depended upon the size of the skip on which they were lowered. This nine-man crew enjoyed their above-ground employment in the sawmill, which was far more desirable than working as a miner. Below, note that the lumber in the background is sitting on the carriage. (Courtesy Fred Thomas.)

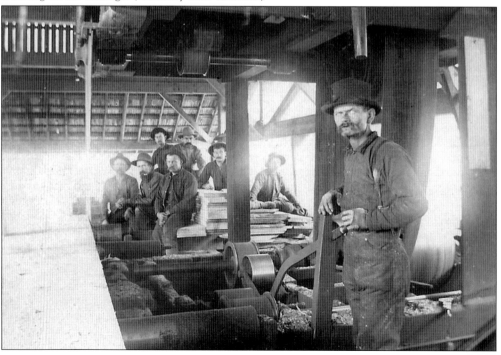

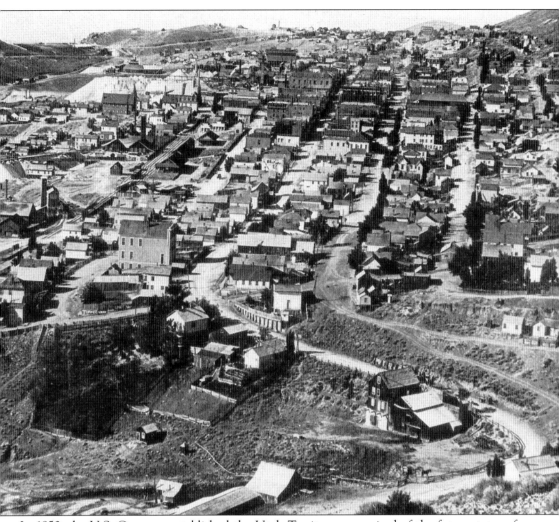

In 1850, the U.S. Congress established the Utah Territory, comprised of the future states of Utah, Idaho, and Nevada. The first trading post in Nevada was established that same year at Mormon Station (now Genoa), which sits at the foot of the Sierra Nevada in the Carson Valley. The post soon boasted a blacksmith shop, mercantile, hotel, corral, and Nevada's first sawmill. For the next 10 years, the territory remained relatively unpopulated. Then, in the late 1850s, a rich outcropping of gold and silver was discovered some 40 miles from Truckee Meadows (Reno). Known as the Comstock Lode, it became the first major deposit of silver ore found in the United States. After the discovery was made public in 1859, prospectors rushed into the area. Virginia City, pictured above, sprang up overnight. Within a year, Nevada's population had grown to over 6,850. (Courtesy Nevada State Library.)

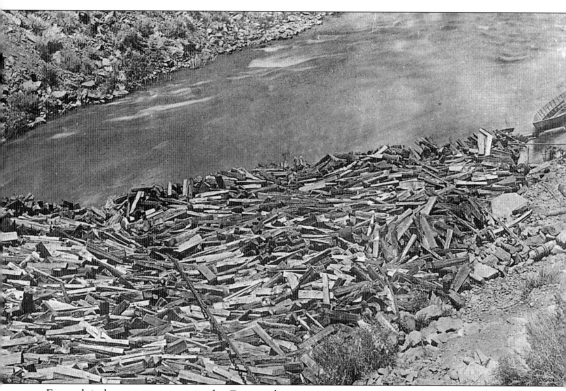

Framed timber was necessary in the Comstock mines to prevent cave-ins. An estimated 1.5 billion feet of lumber was consumed for timbering shafts, drifts, stopes, and winzes, which required the felling of at least 500,000 trees. It was also estimated that the fuel consumed in producing steam for the operation of mine hoists, plants, and stamp mills exceeded the consumption of mine timbering. This required the felling of about one million additional forest trees. Milled lumber was needed for the construction of Virginia City and neighboring towns. Most of these demands were met by the forests on the east slope of the Sierra and in the Tahoe Basin. Log runs brought massive amounts of timber and cordwood down the East Carson River from Alpine County into the Carson Valley as pictured in the above photograph. From there, it was delivered by rail to Virginia City. Note the 30-foot pirogue near the upper right-hand corner. (Courtesy Alpine County Museum.)

Between 1860 and 1862, millions of feet of sawn logs, mining timber, and cordwood ran down the Carson River. By 1864, there had been 14 sawmills built in the watershed, and in 1869, thirteen logging companies engaged in cutting cordwood. Above is a woodcutter's cabin built in the 1860s located near Poison Flat on the Upper East Carson River in Alpine County, California. (Courtesy Alpine County Museum.)

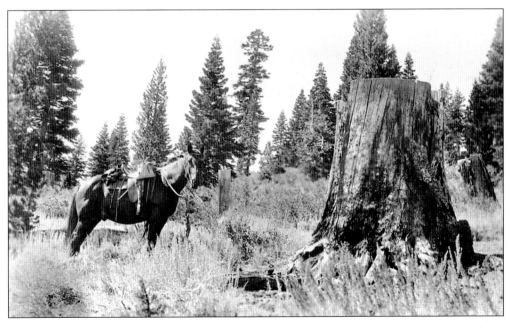

Most of the harvesting took place in the winter so timber and cordwood could be amassed in time for the spring freshet. The above photograph was taken at Indian Creek in Alpine County, California. This old-growth pine was most likely cut during a hard winter when the snow depth was 6 feet or more. (Courtesy Alpine County Museum.)

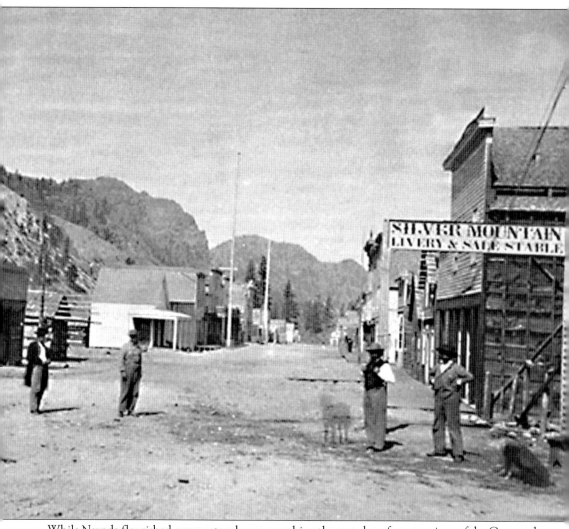

While Nevada flourished, prospectors began searching the east slope for extensions of the Comstock. Mineral deposits were discovered, and soon towns appeared in the rugged high country. Silver Mountain, Raymond, and Summit City boomed and then vanished. The mountainsides that surrounded these towns were by that time devoid of timber. By 1880, over one-third of the Sierra forest on the east slope had disappeared. Pictured on this page is the once-prosperous mining town of Silver Mountain, Alpine County, California. The *Sacramento Daily Union* reported in August 1863, "At present there are more than one thousand men employed here. There are several stores, two or three hotels and restaurants, a baker's shop, a couple of blacksmiths, a score or so of lawyers, only one doctor. . . . If the two mills here could supply the demand for lumber, there would be more than a hundred buildings erected this Fall; but although the mills run night and day, they cannot supply one-fourth the demand." Today nothing remains of this once-flourishing town. (Courtesy Alpine County Museum.)

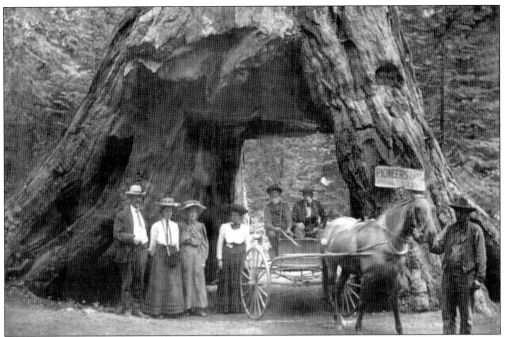

The demand for timber in California and Nevada profoundly changed the Sierra landscape. Between 1855 and 1860, the number of lumber mills in the entire state had increased from 80 to 320. Many were concentrated in the gold country and east slope of the Central Sierra. In an attempt at preservation, the Calaveras Big Trees and Yosemite Valley, singled out for their uniqueness, were taken out of private ownership in 1864 and granted to the State of California. With the enactment of the Federal Forest Reserve Act in 1891, Yosemite became a national park. Pictured above, the Avise family of Amador County visits the Calaveras Big Trees around 1890. Below, this horse and rider, along with his campsite, gives perspective to the enormity of the giant sequoia. (Above, courtesy Dickerman/Dondero collection; below, courtesy Ben Berry collection.)

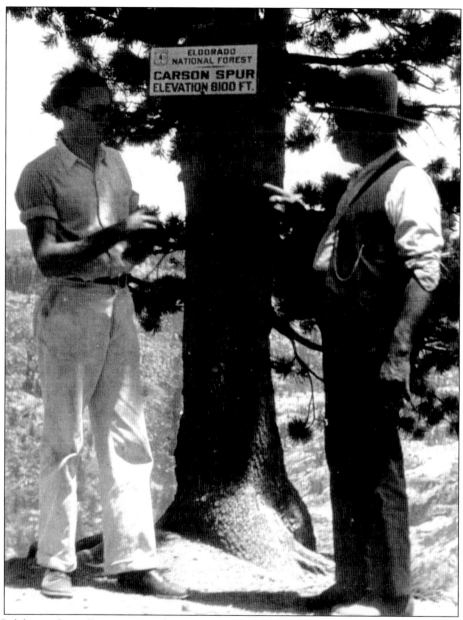

A California State Forestry Board report published in 1886 estimated that over one-third of the Sierra's timber had been consumed or destroyed by fire. A U.S. Geological Survey report claimed that the reproduction of certain species, such as sugar pine and yellow pine, was imperiled because other noncommercial plant species were replacing them. Concerns about the effects of unregulated logging in the Sierra led to public outcry. The Federal Forest Reserve Act under Pres. Benjamin Harrison in 1891 formed the Sierra, Stanislaus, and Tahoe Forest Reserves. Then, in 1905, the U.S. Forest Service was created by Congress and federal control over forested lands was established. In 1907, the early reserves of the Sierra were reorganized into eight more manageable national forests: the Plumas, Tahoe, Toiyabe, El Dorado, Stanislaus, Sierra, Inyo, and Sequoia. Pictured above, Babe Garbarini stands with a forest service ranger at the Carson Spur. (Courtesy Garbarini family.)

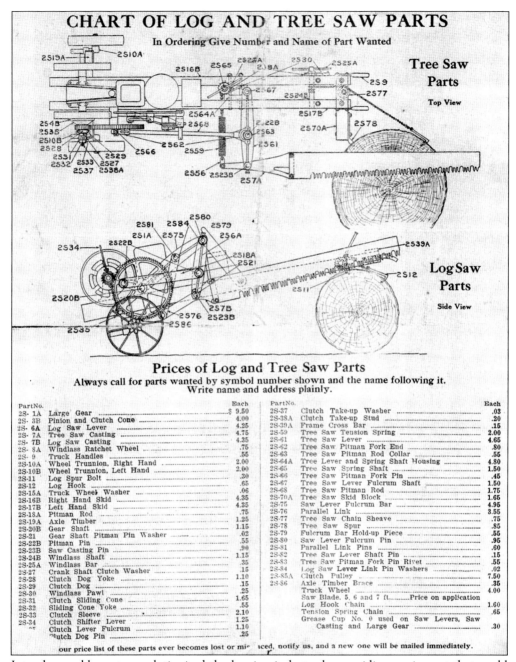

Interchangeable parts revolutionized the logging industry by providing equipment that could easily be repaired. (Courtesy Oneto family.)

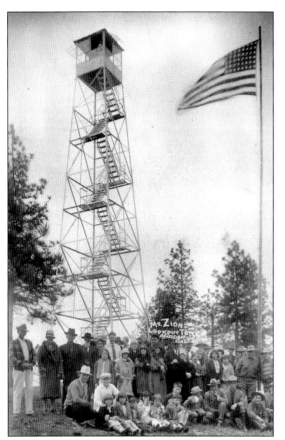

Early foresters were concerned about the detrimental effects of fire. Severe forest fires left hills barren. Burned watersheds contributed to floods on the east slope and in the Mother Lode region. Also of particular concern was the loss of conifer seedlings. A concerted effort was made to reduce fire in the Sierra Nevada, and by the late 1800s, the number of fires was on the decline. Emphasis on fire suppression after 1900 resulted in even further reduction. Fire lookouts such as Mount Zion in Amador County (left) were established throughout the Central Sierra, manned 24 hours a day during the fire season. Below is the crew at Mount Zion around 1935. (Courtesy Ross Oliveto.)

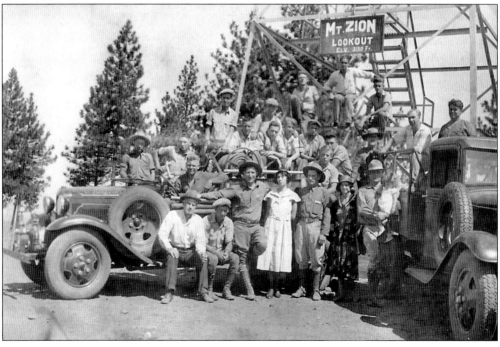

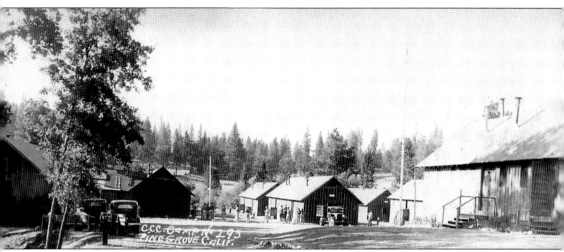

The country, gripped by the Great Depression, was experiencing rampant unemployment and economic chaos by 1933. Pres. Franklin D. Roosevelt initiated several measures during his first 100 days in office. One was the establishment of the Civilian Conservation Corps (CCC), which brought together two wasted resources, the nation's young men and the land. Under Roosevelt's guidance, thousands were recruited into a peacetime army to do battle against soil erosion and the decimation of timber resources. Over three million joined the corps. They worked hard, ate well, and improved millions of acres of federal and state lands. By 1936, some 2,650 camps were in operation, including 150 in California. Some of their nationwide accomplishments included constructing 3,470 fire towers, stringing telephone lines, building 97,000 miles of fire roads, devoting 4,235,000 man-days to fighting fires, and planting more than three billion trees over a nine-year period. Pictured above is the CCC camp located near Pine Grove. (Courtesy Ross Oliveto.)

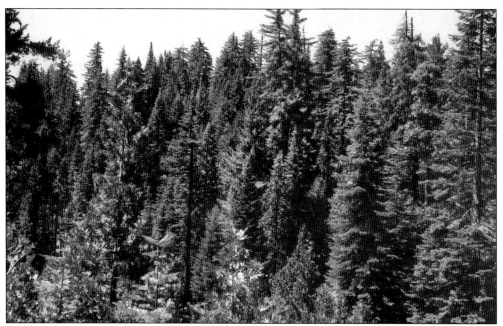

Analysis of fire-scarred trees confirms that historically the Sierra was subject to frequent, low-density surface fires. Fire intervals varied with fuel buildup, weather, and ignitions, but on average, they occurred every 2 to 15 years, keeping the forest thin and preventing the widespread establishment of new trees. Over the last 100 years, fire suppression has allowed for massive buildup of fuels. Above, the Dutch Henry Timber Stand located below Hams Station demonstrates how thick a second-growth forest can become when fires have been suppressed for a long period of time. Below is a painting by Walt Monroe showing the devastation of a high-intensity fire. The Sierra Nevada has become more and more vulnerable to devastating wildfires that destroy everything in their path. (Above, courtesy Ben Berry collection; below, courtesy Alpine County Museum.)

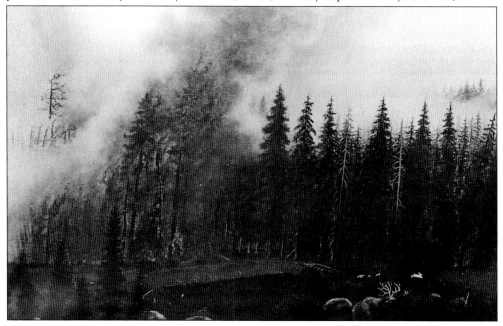

Lumbermen often logged recently burned areas, helping in the cleanup of dead and dying trees. This four-man logging crew is using a gasoline-powered, one-cylinder drag saw to cut cordwood in Alpine County, California, around 1920. The east slope was susceptible to high-intensity fires in second-growth forests because thick vegetation replaced the original pine forests logged in the 1860s. (Courtesy Alpine County Museum.)

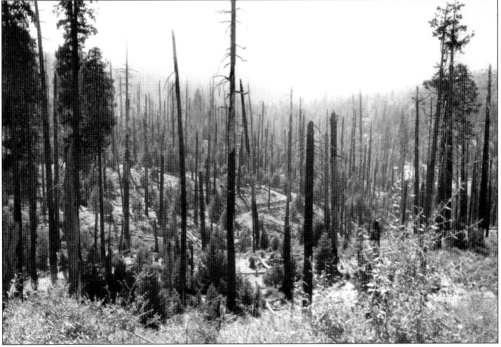

Above is a snag patch located north of Omo Ranch Road in El Dorado County. The fire occurred in 1925. This photograph was taken in 1948. After 20 years, the burnt skeletons still remain, leaving little doubt of the fire's intensity. New-growth fir, pine, and low-lying shrubs are reforesting the area. In the prehistoric forest, the fire most likely would not have destroyed the larger trees. (Courtesy Ben Berry collection.)

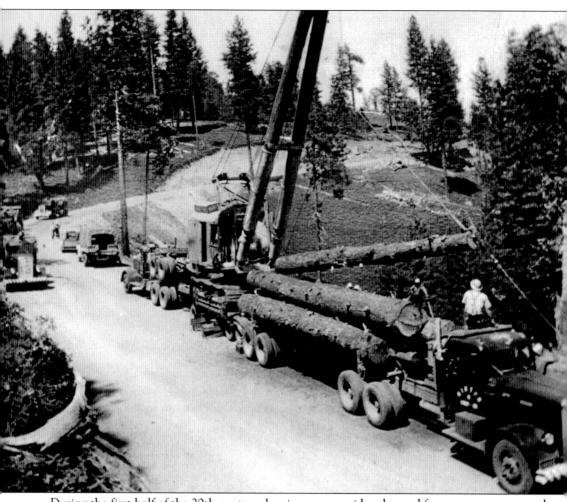

During the first half of the 20th century, logging was considered sound forest management and the most significant contribution to society derived from the national forests. Limited demand for timber between 1907 and 1920, and reduced demand during the Great Depression, suggested that balanced use was relatively easy to maintain. The economic boom after World War II, however, dramatically increased timber demand. Clear-cutting (the removal of all trees from a tract of land) became the dominant form of logging. Between 1902 and 1940, the total timber harvested on the El Dorado National Forest alone was 148.9 million board feet. From 1941 to 1945, it totaled 175.4 million, reflecting wartime demand. Between 1946 and 1959, the harvest total increased to 728.9 million board feet. In just 13 years, more than twice as much timber was harvested on the El Dorado than in the preceding 43 years. Below, the Winton Lumber Company logging crew loads logs with an A-frame crane during the 1950s. The company practiced a policy of selective cutting, which left the forest well-groomed and healthy. (Courtesy Jim Laughton.)

Two

THE EARLY YEARS OF LOGGING

Those few who ventured into the Sierra foothills to harvest timber before 1848 built makeshift sawmills that were abandoned within a season or two. However, when the Gold Rush brought miners into the region, sawmills were quickly established in the mining camps to meet the demand for timber, milled lumber, cordwood, and fuel. These individually run operations harvested from nearby stands and rarely employed more than five men. From these modest beginnings emerged an industry that would become as essential to the developing economy as mining.

The western slope of the Sierra Nevada climbs gradually 50 to 70 miles from the Central Valley to the crest. From the crest, the east face drops steeply into the Great Basin. Four distinctive vegetation zones exist in the mountain range. In the lower foothills along the western edge are the oak woodlands and pine forests. Gold excavation and the first timber harvesting took place in this region. The mixed conifer forest lies on the mid-elevation western slope. By the 1870s, hard rock mining had placed such a large demand on the industry that woodsmen were forced into these higher elevations. Logging crews were employed to harvest old-growth sugar and ponderosa pine and to mill it on-site. Meanwhile, the Nevada Comstock was encouraging the harvest of the east side pine forest that occupies the drier and much steeper eastern slopes of the Sierra. Only the red fir and lodge pole pine forests found in the highest elevations were left untouched during those first decades.

As the logging industry expanded, methods of harvesting and milling improved as well. In the early years, lumber was produced using the pit sawing technique, in which slabs were manually cut by two men pushing and pulling a whipsaw. Circular saw blades soon replaced the whipsaw, increasing production substantially. Within 20 years, steam power had revolutionized the industry. Sawmills became more elaborate, adapting new technologies to the unique Sierra landscape.

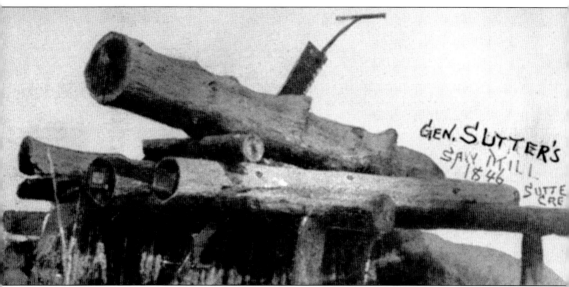

Prior to the Gold Rush, Euro-Americans came into the Central Sierra foothills to harvest timber. In 1846, John Sutter of Sutter's Fort at New Helvetia (now Sacramento) needed lumber for a ferry. He set up a small mill in a stand of sugar pines located on the ridge four miles above what is now Amador City and Sutter Creek. Here is a depiction of this first sawmill, in which the pit sawing method was employed. A platform, held up by pole trestles, was built over a pit. Logs were squared with a broad ax and lifted onto the platform. One man would either straddle or stand on the log (topman), and a second man worked underneath (pitman). They used a 6-to-8-foot-long whipsaw with ends fitted with tiller-type handles. The two men pushed and pulled, cutting on the downward stroke only. Using this back-breaking process, two men could cut about 200 lineal feet of construction lumber per day. (Courtesy Ross Oliveto.)

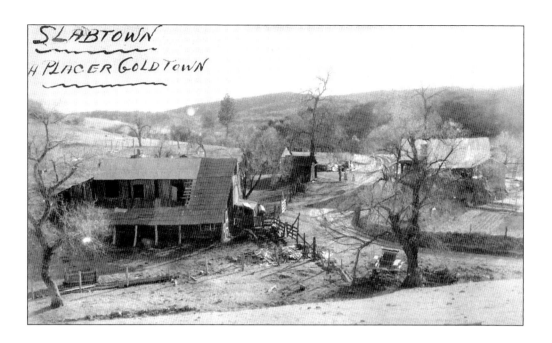

With the California Gold Rush, mining camps sprang up overnight. Sawmills were quickly constructed to meet the demand for lumber. These early mills employed the pit sawing method. Timber was readily available from nearby stands and easily harvested. By 1860, there were 15 sawmills in Amador County alone, cutting 11.5 million feet of lumber per year. The old mining camp of Slabtown was located on Butte Mountain Road between Jackson and Pine Grove. Only a few buildings remain of this once-thriving community. The sawmill pictured below was built in the 1850s. It was later converted into a barn after mining gave way to agriculture. (Courtesy Ross Oliveto.)

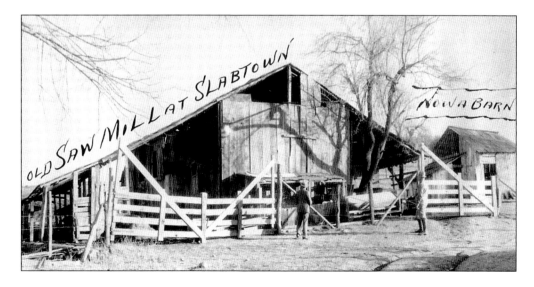

"Sash mills," with saw blades powered by old-fashioned waterwheels, soon replaced pit sawing. The heavy-gauge blades, from 8 to 12 inches wide and 6 to 8 feet long, were secured to the sash or wooden saw frame. Only one man was required to operate a sash mill. With an automatic carriage feed and stop, he could simply start the carriage and then leave it to take care of lumber, slabs, and endings. When the saw line was finished, he would return to the operation, gig back the carriage, and set the log for the next cut with a pinch bar. The process would start again. Sash mills usually cut between 500 and 1,500 feet per day, depending upon the water availability. This photograph, taken in Amador County, shows a long-abandoned mill site. Sash mills were crudely constructed next to creeks and, once the cut ran out, were usually vacated. The lumberman would move on to another location. (Courtesy Dickerman/Dondero family.)

As timber supplies dwindled in the foothills, lumbering shifted into the higher elevations. There sawmills became more elaborate, operated seasonally, and required more manpower. The Farnham Sawmill of El Dorado County (shown around 1875) employed an eight-man logging crew. The company utilized the "hand-logging" method of harvesting. A steep chute, seen coming down the slope to the left of the buildings, was constructed to deliver logs to the sawmill. A cross-ribbing of short logs was often laid on the slope above to act as skids. Once a tree was felled and lying on the skids, it was "bucked," its branches lopped off close to the bark. With the use of a jack, the tree was then skidded to the chute. It would "run" down the slope at an inconceivable speed and with a tremendous crushing noise come to rest on the landing. The crew milled the felled timber using steam-powered circular saws, as evidenced by the boiler. Cabins were constructed to house the loggers during the summer season. (Courtesy Amador County Archives.)

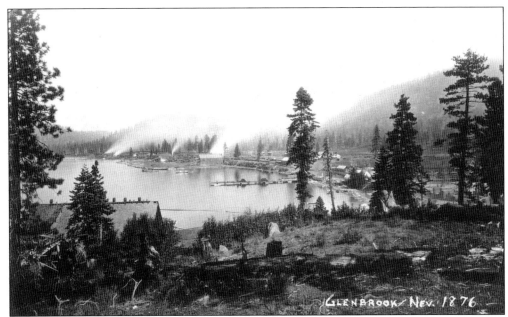

Logging companies were also forming along the east slope in response to the Comstock Lode. The Tahoe Basin was easily accessible. Its first sawmill, the steam-powered Monitor, was built in 1861 at Glenbrook by Capt. Augustus W. Pray. Duane L. Bliss, head of the Carson and Tahoe Lumber and Fluming Company, acquired it in 1872, along with several large tracts of land in the Tahoe Basin. Pictured above is a view of Glenbrook Bay in 1876 showing the sawmill, breakwater, and company steamers. Bliss controlled over 50,000 acres of timberland in and around Lake Tahoe. In a 20-year span, an estimated 750 million board feet of lumber and 500,000 cords of wood were harvested, hauled to Glenbrook by tugboat for milling, and then delivered to Virginia City. Below is the mill as it appeared in 1893. (Courtesy Douglas County Historical Society.)

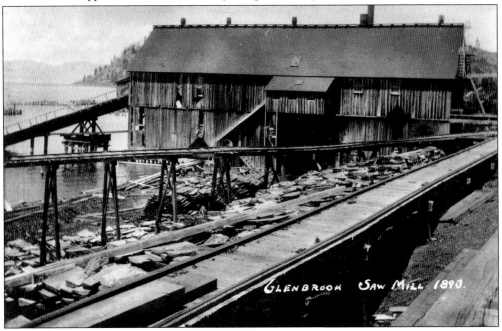

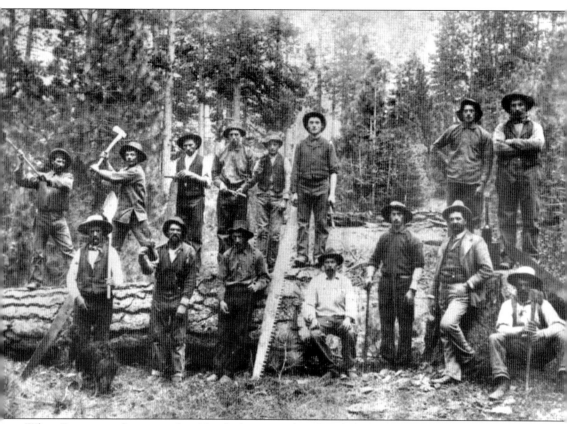

When Europeans first arrived in North America, they found the techniques and tools used in Europe for timber harvesting were inadequate against the larger trees found in the New World. New methods and equipment quickly developed. For example, the single-bitted felling ax evolved, and by the 1830s, they were steel cast. Other equipment included whipsaws, jacks, cant hooks or peaveys, ring dogs, and blocks and tackle used to wrestle logs. When the miners first arrived in California, they brought this technology with them. Within a decade, many had turned from mining to more lucrative employment in the woods. Although seasonal, signing on with a logging company was a guaranteed paycheck. Pictured above, the Glenbrook logging crew of the Tahoe Basin displayed the tools of their trade: whipsaws, axes, wedges, mauls, and shovels. Two loggers identified in this photograph are Fred DeGiovanni, standing on the log second from the left, and his brother, Charles Domenico DeGiovanni, standing fifth from the left. (Courtesy Douglas County Museum.)

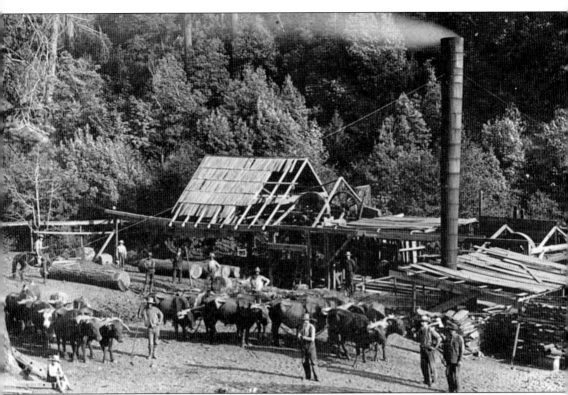

The on-site processing of felled timber was necessary in the high country to reduce size and weight before transporting. This method required more sophisticated technology. By 1885, stationary steam engines and boilers were being shipped west from Chicago. Circular saw equipment had been refined, and with steam, mills could produce 10 to 20 times the footage they had in earlier years. These mills used a circular head saw from 30 to 48 inches in diameter for ripping logs and one or more cut-off saws for cutting boards to length, producing rough-cut lumber. This photograph of the Mace Sawmill was taken in the summer of 1889 after a hard winter crushed in the roof. The saw blades are plainly visible, along with the carriage, log deck, and boiler stack. The oxen team was used for hauling and yarding. Pictured from left to right are (foreground) eight-year-old Fay "Bud" Mace (seated), Jim Lessley, Giddings Pickard, Leroy Jones, and T. Bachelor; (background) Hale Mace on his horse Lily, Lee Nichols, Wes Nichols, Sam Emmons, and Ty and Jack Porter. (Courtesy Amador County Archives.)

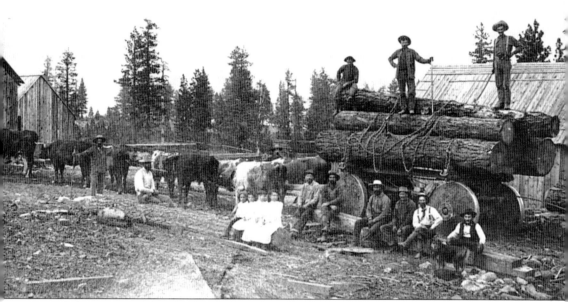

Pictured above around 1888 is the Cohn Sawmill of Alpine County, originally known as the Bermis mill and located northwest of Markleeville. Its steam-powered circular saw was purported to have cut 25,000 to 35,000 feet daily. When timber became scarce, the mill was moved to the Hawkins Ranch and renamed. Oxen were used to pull the large-wheeled cart. These carts were common to the rugged terrain found in the sugar pine region of California. The wheels on this type of cart were anywhere from 6 to 12 feet in diameter and 5 to 10 inches wide. They could easily straddle tall obstructions in the roadway while keeping the load steady and balanced high above the ground. Load chains were used to secure the logs. Families often joined the loggers during the summer harvest, as indicated by the children seated in the foreground. (Courtesy Alpine County Museum.)

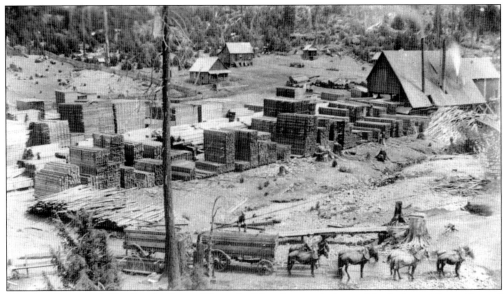

The family-owned Chichizola Sawmill supplied lumber to their yard in Jackson Gate. One of the largest mills in the region from the 1880s into the 1900s, it was located near Cook's Station. A log pond, almost dry in late summer, is seen in the lower right-hand corner. Once milled, the lumber is stacked to air dry before delivery. (Courtesy Amador County Archives.)

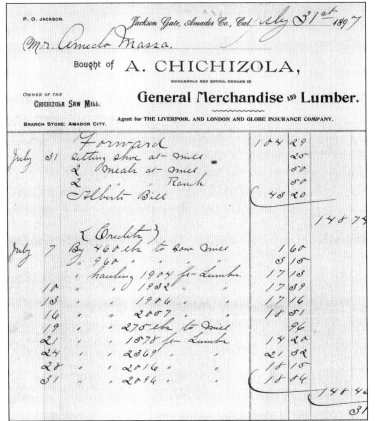

This receipt from A. Chichizola General Merchandise and Lumber indicates that Amedeo Massa traded merchandise for his services in hauling lumber to the lumberyard. (Courtesy Giurlani family.)

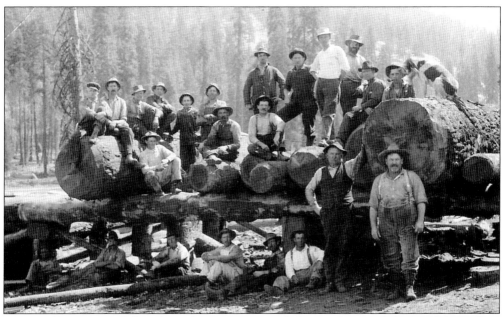

Most small operations did not have the convenience of a log pond. Instead they used the method of dry decking. Timber would be harvested, temporarily stored on a dry deck, and milled within days. The mill crew, pictured above, is standing on a dry deck, which consisted of a peeled log trestle supported by short legs. (Courtesy Ben Berry collection.)

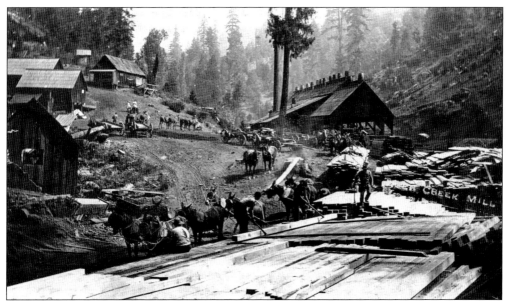

The Speer Creek Mill of Calaveras County provided square-cut timber to the mines, as well as dimensional lumber. (Courtesy Amador County Archives.)

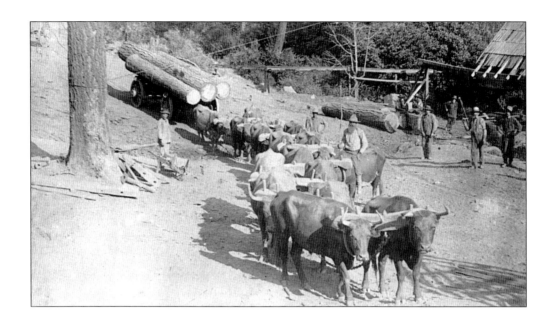

Draught animals were essential to the larger logging outfits that required the hauling of timber to a sawmill some distance away. Above, the company-owned oxen team delivers logs to Mace's Sawmill. Bull whacker Jack Porter is seated on the back of one animal. Ling, the Chinese cook, is seen with his wheelbarrow near the tree. Others pictured from left to right are Jim Lessley (standing), Wes Nichols and Leroy Jones (seated on logs), and Sam Emmons, D. Pickard, and Al Cottingham (standing). Below, the Whitmore Mill oxen team is shown hauling sugar pine to the mines. In the early days of logging, oxen teams played an important role in the transport of vast amounts of timber, lumber, and cordwood to the California gold fields and the Nevada Comstock. (Courtesy Amador County Archives.)

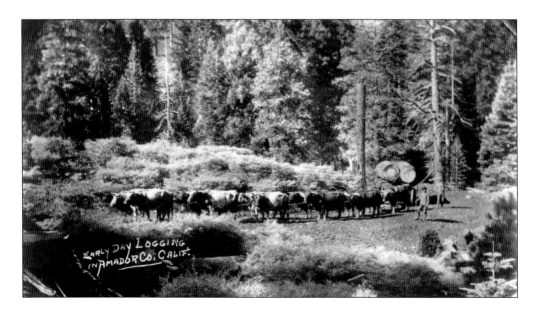

Three
EARLY TRANSPORTATION

Transporting timber was the greatest problem facing Sierra lumbermen. This was particularly true in the higher elevations where larger, more permanent mills had been constructed or in rugged terrain where assembling a portable mill was not feasible. The initial difficulty arose in the transport of the felled log to a collection point, usually a skidway, yard, or depot. Once assembled in one location, the logs were then hauled to a sawmill for processing. The final transportation dilemma involved getting the milled lumber to distant markets.

Draught animals—oxen, horses, or mules—were employed at the point of felling, along the skidway, in yarding, and by teamsters for delivery. In many instances, however, the use of draught animals was not feasible.

California loggers initially turned to the time-proven methods of the East, where water flow was the primary means of delivery. Unfortunately, the exploit of rivers and streams for transportation in California could only be applied in certain regions and was seasonal at best. Flumes and canals were used to some extent, but the rugged Sierra landscape limited their utilization.

With the construction of railroads, transportation of timber and lumber to distant markets was enhanced. Narrow-gauge railways were also employed in the woods to transport logs short distances. The invention of the donkey engine and the utilization of the steam traction engine began the modernization of the logging industry.

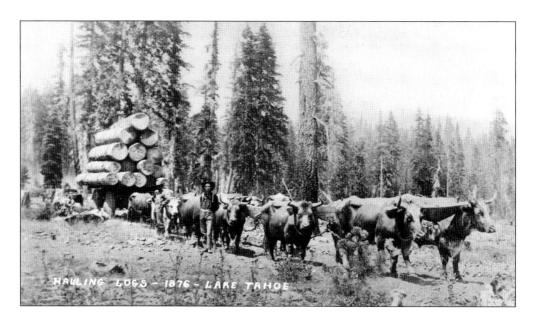

Oxen were the first draught animals employed in the woods. Although slow on short hauls, oxen could be loaded more heavily than other draught animals. They were less excitable, required minimal attention, and needed only one feeding per day. Another advantage was that a 12-animal team could easily be handled by one teamster. The above photograph, taken in the Tahoe Basin in 1876, demonstrates the heavy load that an oxen team was capable of pulling. Note the practice of clear-cutting in the foreground and the virgin pine stands in the background. The photograph below illustrates how the oxen were yoked and chained. These brawny animals could easily pull 15,000 pounds of dead weight. The bull whackers, standing to the right of the animals holding goads, controlled the teams. (Above, courtesy Douglas County Museum; below, courtesy Amador County Archives.)

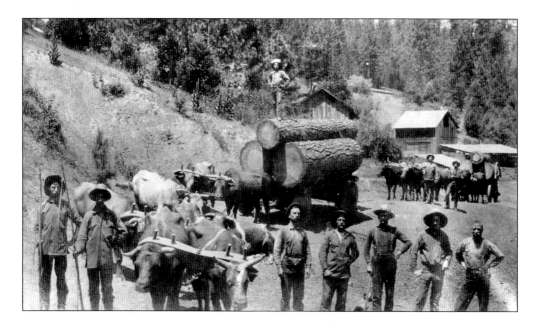

Draught animals also supplied power for decking logs on skidways and landings and for loading logs on sleds, wagons, and logging cars. Oxen were often the only animals used for this purpose by many of the pioneer lumbermen. These loggers, operating in remote sections of the Sierra, found the ox more desirable than other draught animals because it could live on coarse feed, pull heavy loads, and stand rough treatment. Looking at the above photograph, taken in the Amador County high country, it is easy to imagine the sound of pounding hooves, the heaving of muscle, and the curses of the bull whacker as he strikes the pointed rod of his goad across straining flesh. The highest paid of a logging crew, the whacker prodded and tongue-lashed his oxen, keeping the cut moving as fast as possible. And if an ox should fall victim to an accident, as they often did, it could be served as supper in the dining hall that evening. (Courtesy Ross Oliveto.)

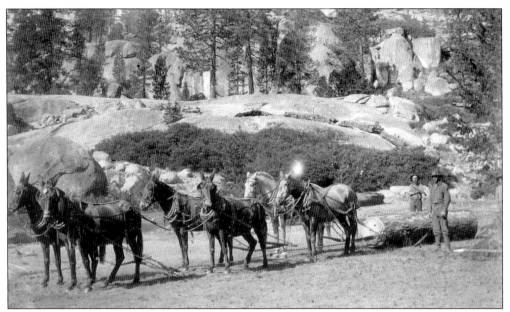

Smaller logging operations sometimes preferred mules or horses. More active than oxen, these draught animals were better adapted to handle lighter timber. Although they were faster and more easily handled than oxen, the disadvantage was that only four or five animals could be worked by one man. Above, loggers use a horse-and-mule team to pull logs through the granite-laden Blue Lakes region of Alpine County. (Courtesy Fregulia collection.)

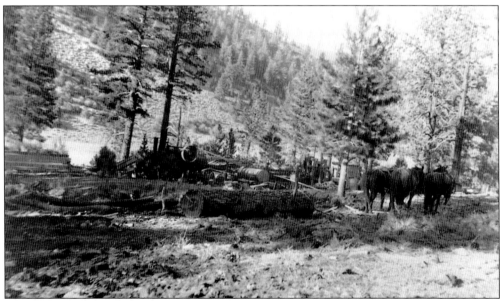

Animal power was also used in the milling process. This sawmill, located in Alpine County, was equipped to cut logs into manageable lengths for delivery down to the Carson Valley. Horses dragged logs into the mill, where the logs were ripped by a circular head saw. (Courtesy Alpine County Museum.)

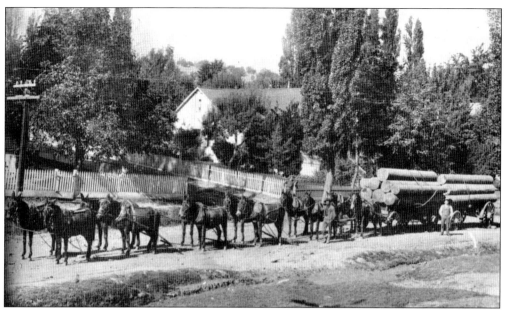

Teamsters throughout the mining regions of California and Nevada made their livings hauling timber to the mines. They owned their own draught animals, usually mule teams, and were paid according to the haul. Mules were well suited for hauling in the hot Mother Lode and Great Basin regions, being better able to withstand the direct rays of the sun, the dusty roads, and the demand for speed placed upon them by their handlers. Above, this 12-mule team hauled a double wagonload of logs along Badger Street in Sutter Creek. Below, Mr. Podesta's mule team is hauling logs down what would later be known as Raggio Road between Ridge Road and Jackson Gate. (Above, courtesy Ross Oliveto; below, courtesy Amador County Archives.)

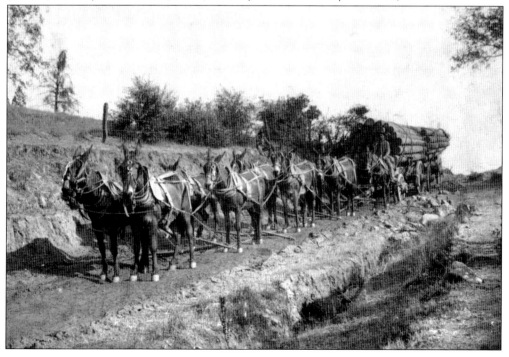

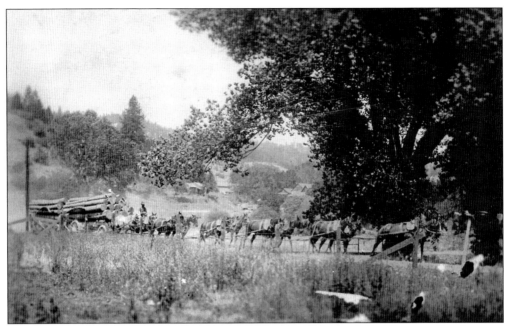
The logging of second-growth pine continued for decades in the foothills. These smaller-diameter poles were harvested and transported to the mines each year. Above, this 12-mule team, belonging to the Garibaldi family of Volcano, pulls two wagonloads of freshly harvested, small-diameter pine. (Courtesy Gary Medina.)

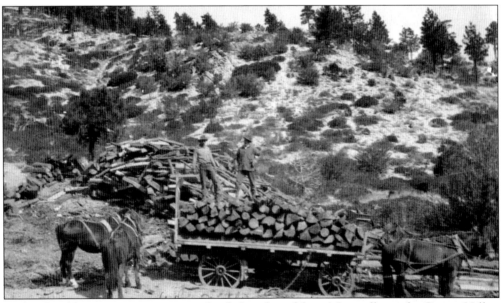
Arthur Brockliss, wearing an overcoat, hauled cordwood from Mottsville, in the Carson Valley, to Virginia City using his four-horse team. A cabled conveyor line had carried the cordwood to this point, where it was quickly unloaded. From here, it was hauled by wagon to the mines. The surrounding mountainsides were once heavily timbered. (Courtesy Douglas County Historical Society.)

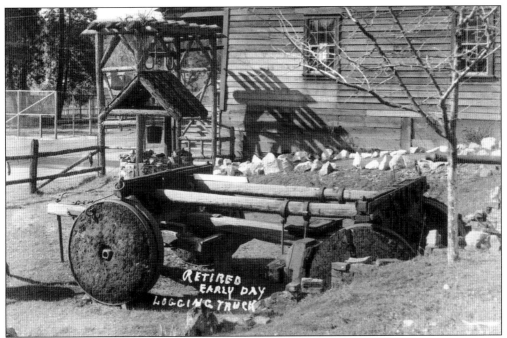

The above pictured "Logging Truck" was pulled by draught animals. The wooden wheels used on this cart, known as "lily pads," were wood slabs cut from a select, good-grade log. A blacksmith would then fashion metal bands to fit around the slab and heat shrink it around the wood. The middle was then bored out to accept the axle. (Courtesy Amador County Archives.)

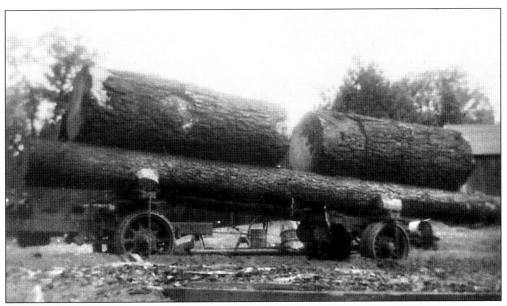

As time went on, the logging truck was modified to haul longer, heavier loads. The truck pictured above had disconnected axles with a pivot bunk on the back frame. Logs were chained to both the front axle and the rear disconnect axle, serving as the only connection between the two. (Courtesy Ben Berry collection.)

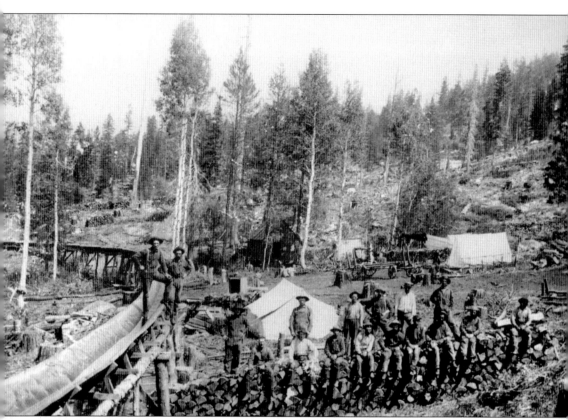

The demand for timber, especially on the east slope during the Comstock, could not be met by conventional draught power. It was far more expedient to send lumber and cordwood down the steep mountain slopes by flume, utilizing water and gravity. In 1867, James Haines of Genoa, Nevada, invented the V-shaped flume. Each section consisted of two boards—each 2 feet wide, 1.5 inches thick, and 16 feet long—joined at right angles. The structure was supported by trestlework. The cost of timber and cordwood was greatly reduced by this invention, giving the mining industry of Nevada a tremendous boost. The Carson and Tahoe Lumber and Fluming Company purchased the Glenbrook Flume in 1873 and used it to deliver timber from Spooner Summit into Carson City. This 14-mile-long V-flume took two million feet of lumber to construct and could deliver 500,000 feet of cordwood per day. The Glenbrook crew is seated upon a pile of cordwood ready for transport. The tent camp provided temporary lodging during the seasonal harvest. (Courtesy Douglas County Museum.)

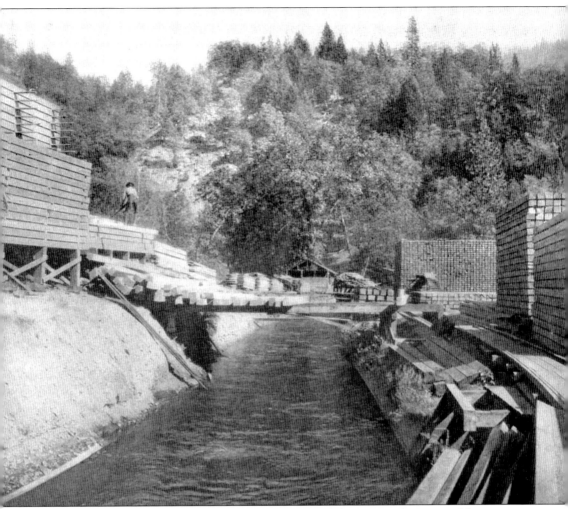

Historically, lumbermen from the eastern states used the elaborate canal systems of that region to transport harvested timber. Applying this age-old method, hundreds of miles of narrow canals were constructed in the Sierra by 1900, using alpine rivers and streams as their source of water. These canals not only transported wood but also delivered water to mining and agricultural ventures in the Carson Valley and the Mother Lode regions of California. The original 43-mile-long Amador Canal, pictured above, took water from the Mokelumne River in the High Sierra and transported it to Jackson, Sutter Creek, and surrounding region. When constructed in 1870, its intended use was multipurpose, including the transport of raw timber. Later, when the canal system was purchased by consecutive utilities, its flow was still utilized for the transportation of logs and milled lumber. Above is the Pacific Gas and Electric Company canal lumberyard around 1930. (Courtesy Fregulia collection.)

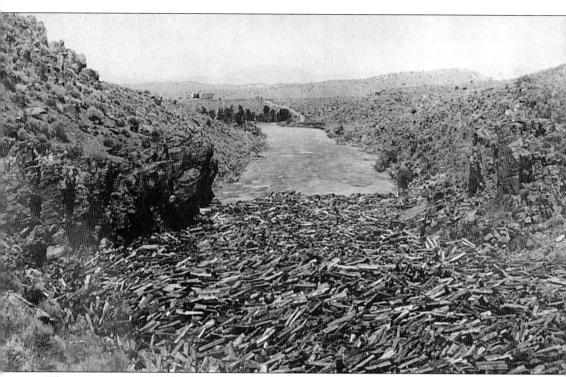

The greatest example of utilizing water for transport was the wood drives on the East Carson River. Between 1860 and 1862, millions of feet of sawn logs, mining timber, and cordwood floated down the river with the spring thaw. Cut timber, harvested in winter, was stored behind a log dam built on a narrow part of the river. With the spring freshet, the dam, by then filled to capacity, was blown up, and virgin yellow pine timber was run down to Empire, Nevada. There were as many as six log drives in the East Carson each spring, taking an average of 22 days. The river was filled with wood 6 feet deep, stretching a distance of 4.5 miles upstream. Occasionally heavy rains caused an unexpected heavy thaw. The volume of water caused the dam to break early, sweeping wood down into the Carson Valley, where it lay scattered on the valley floor. It was gathered up and hauled back to the river by teams. The largest drive was said to have contained about 150,000 cords. (Courtesy Alpine County Museum.)

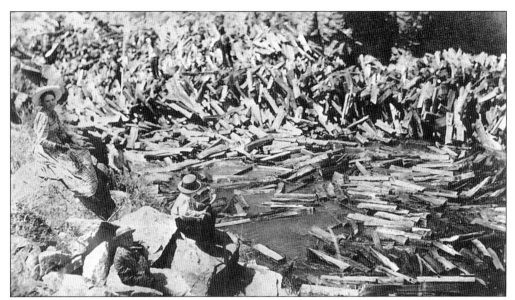

Just before the drive, men were stationed along the river to tend to its progress. They were armed with long hooked poles, "pickaroons," which they used to keep the logs moving. In the photograph above taken at Herrick Landing, Alpine County, men with pickaroons stand on a log jam to break it apart. A young woman and her sons watch from the bank. (Courtesy Alpine County Museum.)

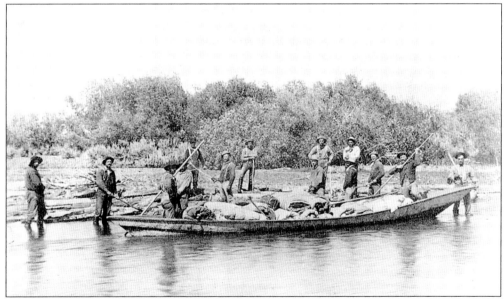

The drive was piloted by lumberjacks who kept the logs moving. Their bedrolls and food followed in the 30-foot pirogue, above. Pictured from left to right are V. S. Garbarini (Amador County), James Audrain, Louis Bergevin (in boat), Frank Audrain (in boat), James Grace, Jack Brighton, Esau Pete (Native American), Charles Buell (Native American), Jack Bartlett, Barney McGowan, Sam Cowan, True Van Sickle, James Campbell (in boat), and John Bryant. (Courtesy Evelyn Gillick Garbarini.)

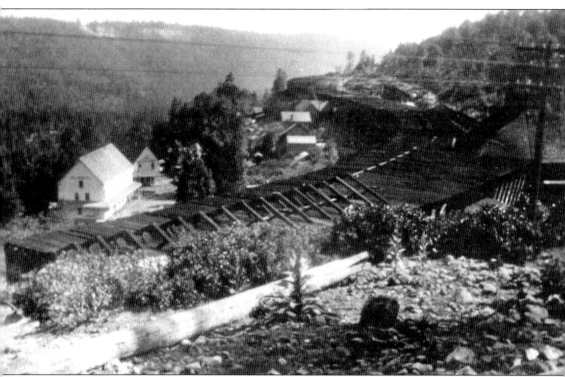

Using railroads to transport lumber to distant markets began with the construction of the Central Pacific in the late 1860s. Initially construction required vast quantities of timber for ties, bridge material, station buildings, snowsheds, and water towers. The Central Pacific received, with its right-of-way through the Sierra, 20 alternate sections of land on either side that provided much of the timber used in construction. Wood was needed as fuel to fire the steam engine boilers. Pictured above, the railroad snowsheds near the western summit required 300 million board feet for construction. Another 20 million board feet was consumed annually to keep the buildings in good repair. Once completed, the Central Pacific provided an inexpensive means of shipping lumber to Virginia City, Salt Lake City, and other communities in the barren Great Basin. (Courtesy Fregulia collection.)

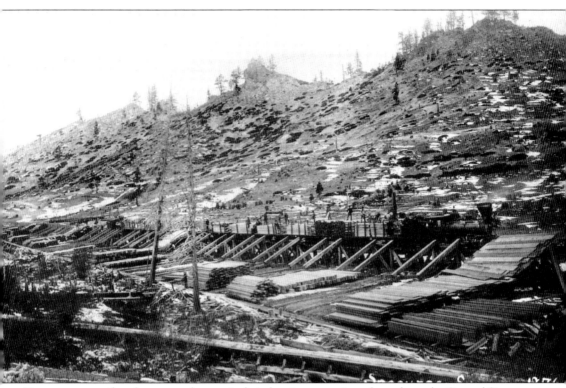

Narrow-gauge railroads were used extensively in logging operations throughout the Central Sierra. Defined as using rails placed 3 feet apart, rather than the standard 4 feet, 8.5 inches, narrow-gauge rail lines were popular in the mountainous terrain because they required a minimum radius on curves and were less expensive to build and operate. Small, steam-powered Shay locomotives, weighing 65,000 pounds, were specially built to pull the heavy loads on flat cars through the rugged terrain. One of the first narrow-gauge railroads was constructed in 1875 by the Carson and Tahoe Lumber and Fluming Company. Pictured above, the 8.75-mile line was used to transport lumber and cordwood from the Glenwood Sawmill on the Lake Tahoe shore to the top of Spooner Summit. At the summit, the flat cars were unloaded on the landing and then sent down to Carson City on the V-flume, shown at the bottom of the photograph. Two locomotives were employed, the *Glenwood* and the *Tahoe*. Over 300,000 board feet of lumber and cordwood passed over Spooner Summit each day. (Courtesy Douglas County Museum.)

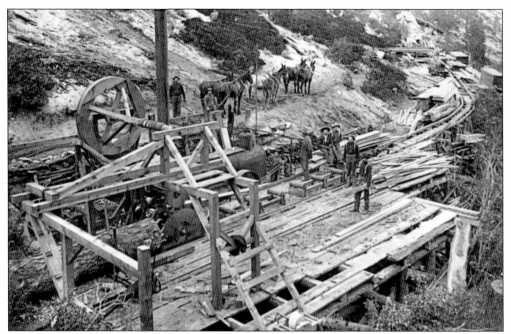

Mules were used to drag logs along narrow-gauge rail tracks at this sawmill located in the mountains above Carson Valley. Once sawn, lumber was then transported to the yard along the off-bearing track. This two-story mill used a single-blade circular saw operated by the locomotive-style steam engine boiler under the log deck. (Courtesy Douglas County Museum.)

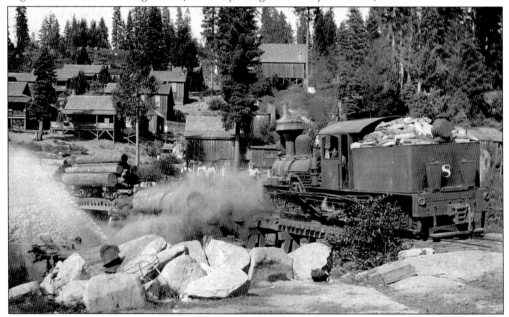

Above, a flat car is being unloaded into the log pond of an Amador County sawmill. Note the cordwood stored in the locomotive's box. Although the steam engine's boiler burned vast quantities of wood, fuel was always plentiful. Logging railroads were hastily built and designed for temporary use. Once the timber was harvested in a given area, the rails were pulled to be reused elsewhere. (Courtesy Amador County Archives.)

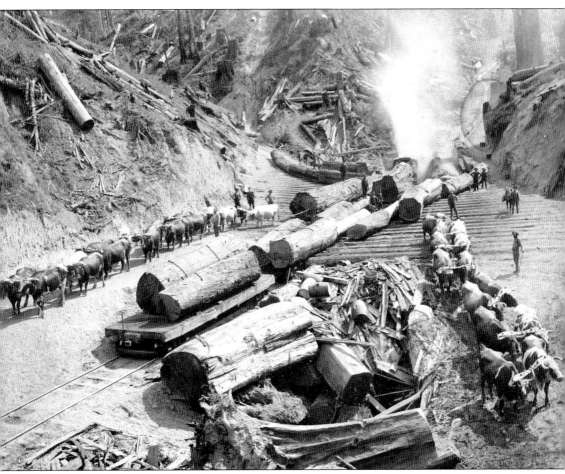

Featured on the cover, this photograph provides a perfect illustration of the workings of a Central Sierra steam rail logging operation. This c. 1890 outfit, located at the head of a canyon in Amador County, used two teams of oxen, a locomotive, railcars, and a flume to meet its transportation needs. The flume carried logs from the slopes above. Upon reaching the terminus, the logs landed on the rollway, which was a stout skid with 20-inch-wide logs embedded crosswise in the ground to half their diameter. A pitch of one-half inch to the foot was usually given to bed skids to facilitate the rolling of logs. The oxen teams dragged the logs along the rollway and aided in the loading of the railcars. The logs were then delivered by locomotive to a sawmill. This photograph suggests wasteful logging practices that left the ground littered with discarded material. There seemed to be little concern over the potential erosion of clear-cut slopes. (Courtesy Amador County Archives.)

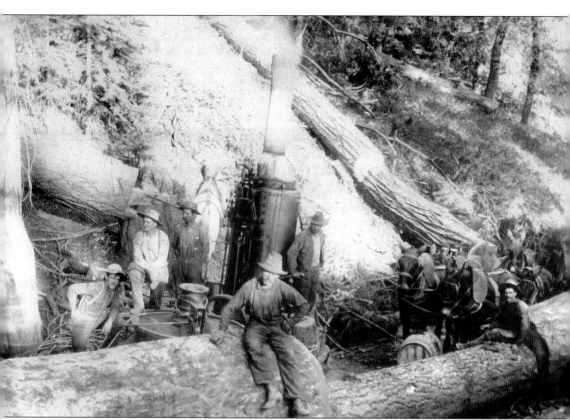

Loggers began looking towards mechanization to replace draught animals in the woods. The steam-powered donkey engine, named for the animals it replaced, was invented in 1881 by John Dolbeer, a marine engineer from Crescent City, California. Dolbeer married a vertical fire tube boiler with a steam-driven capstan or winching drum. He wrapped a gypsy head (a vertically mounted spool) and attached the other end to a log. The donkey would then pull the log toward the engine. This stationary steam engine could haul logs in almost every imaginable setting and circumstance. Above is an early vertical spool donkey used by the Chichizola's Sawmill, Amador County, around 1885. The horses were used to return the gypsy line to the chokerman for another turn of logs. Fueled by bark, limbs, and other logging waste, the donkey was most commonly used in yarding, skidding, and loading. These steam machines transformed the logging industry in a few short years because they enabled workers to log areas much faster than when logs were hauled solely with oxen, horses, and mules. (Courtesy of Babe Garbarini.)

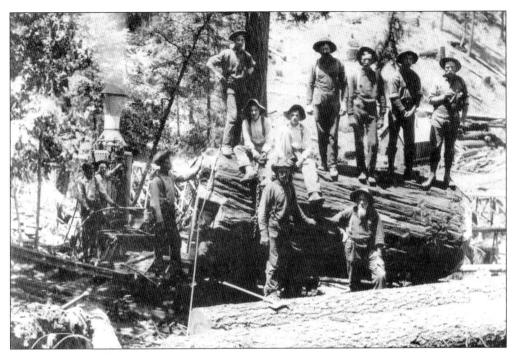

Most strides toward increasing production and reducing the cost of logging came in the yarding of logs—that process of hauling logs from the stump to yards or landings for transport. The invention of the donkey engine allowed loggers to harvest previously inaccessible timber. Above, the Whitmore logging crew of Amador County poses with their donkey around 1885. Rail tracks had been temporarily laid to skid logs. (Courtesy Ben Berry collection.)

Eventually, steam donkeys were built with multiple horizontally mounted drums/spools and used heavy steel cable instead of rope. Sheet-metal roofs, known as "donkey houses," were built over the top. At right, a later model double-drum donkey used heavy-duty coils attached to a cable winch to drag logs to a landing. Logging operations had advanced into the age of mechanical power. (Courtesy Amador County Archives.)

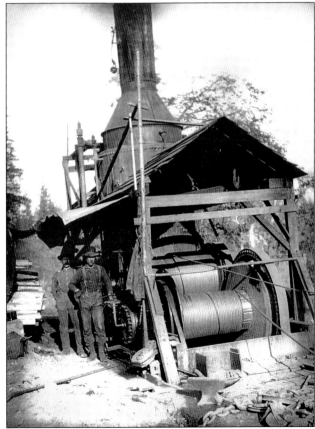

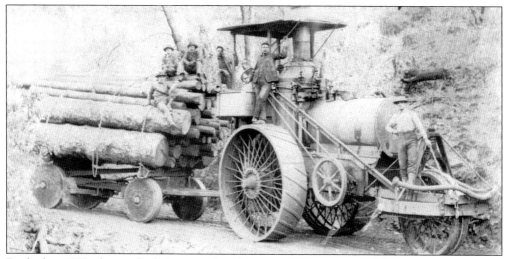

By the late 1890s, loggers had also turned to the traction engine, or road locomotive, for hauling purposes. First introduced in the East for agricultural use, they were extremely heavy, slow, and difficult to maneuver. They nevertheless revolutionized the logging industry. Their operation usually required a crew of three to five men—namely, the engineer, a fireman, a pilot, and "trainsmen"—depending upon the number of sleds hauled. The average speed with loaded sleds was four to five miles per hour. In the photograph above taken near Oroville, California, a three-wheeled Best traction engine is towing a log truck equipped with concrete wheels. Below is a frontal view of a three-wheeled traction engine used to haul lumber from the east slope. The Best Manufacturing Company was located in San Leandro, California. (Above, courtesy Ben Berry collection; below, courtesy Douglas County Museum.)

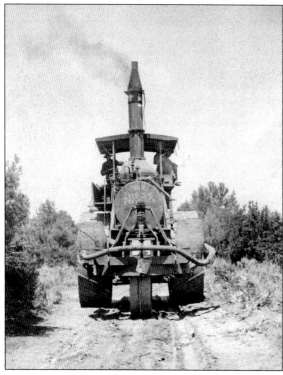

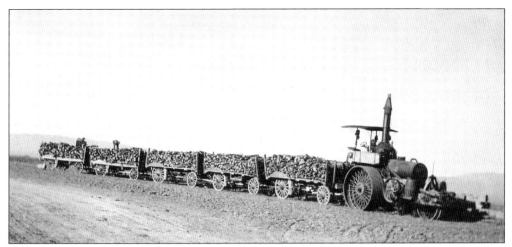

Traction engines were often used when the amount of timber hauled did not warrant the construction of a railroad. The engines required a solid stone road and dry weather. During rainy periods, the traction wheels made roads impassable. Above, the traction engine was ideal for transporting cordwood from the Sierra to the mines of Nevada. (Courtesy Douglas County Museum.)

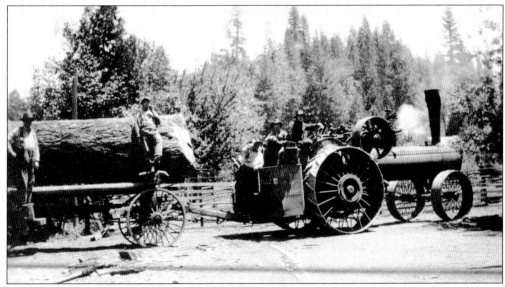

This traction engine belonged to the Farnham sawmill of El Dorado County around 1910. Robert Jameson is standing on the far right. This steam engine could easily move heavy loads of logs but, unlike animals, operated both day and night. As it was fueled by easily attainable wood, rather than by hay, it was far more economical to operate than draught animals. (Courtesy Amador County Archives.)

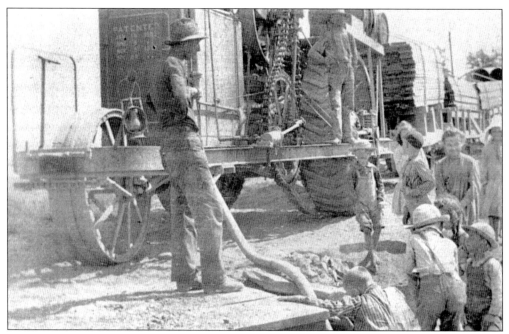

Above, a three-wheeled traction engine, while passing through the Jackson Valley, stopped alongside a creek to pump water into its engine. The young children watching were obviously enthralled with the operation. In Amador County, traction engines could only operate during the summer months when the roads were passable. (Courtesy Fregulia collection.)

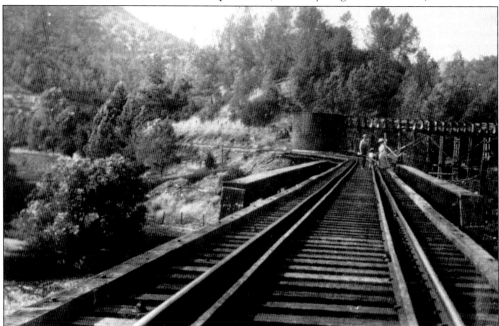

Meanwhile, the railroad lumber industry continued to expand, reaching its peak between 1890 and 1920. More than 80 rail logging companies were created. The areas most affected were the Tahoe Truckee Basin and the El Dorado and Stanislaus National Forests. Pictured above, a railroad bridge passes over the Stanislaus River in the California gold country. (Courtesy Fregulia collection.)

Four

TWENTIETH-CENTURY ADVANCES

Mining activity wound down during the decades leading up to the century mark, resulting in a decrease in timber harvests. After 1900, demand once again shot up. Advances in logging equipment and modes of transportation made the industry more efficient. The heightened demand, coupled with this new technology, generated a logging boom following World War I. Individual sawmill operations differing in size and equipment sprang up throughout the Central Sierra.

Free government timber, a team to haul logs, and a steam-powered traction engine allowed one-to-five-man outfits to operate small, portable sawmills successfully. The mills were hauled into the high country either by draught animals or traction engine, operated during the summer season, and then disassembled and moved when the cut ran out.

Larger, more permanent, high-production, steam-powered sawmills were constructed at elevations between 2,000 to 6,000 feet. With modern mechanized equipment and assembly-line-style production, these high-speed mills were capable of cutting millions of board feet of lumber. They easily engaged 100 or more personnel and became one of the biggest employers in the region.

Although the Great Depression brought decline to the industry, business improved during World War II and accelerated after the war. As the 20th century progressed, new innovative equipment found its way into the forest. Steam power eventually gave way to the gasoline engine and then finally to diesel. Electricity became available to many mills. By mid-century, timber harvesting was at its peak.

By the early 1960s, the U.S. Forest Service determined that harvest levels had reached the land's capacity to produce for sustained yields. The harvest was stabilized and remained constant until 1990. At that time, logging was shifted to forests that had been damaged by wildfires or insect and disease infestations. Since 1988, conservation and wildlife habitat concerns have reduced timber harvests in the Sierra by two-thirds. Today the forest is no longer managed for the benefit of timber production.

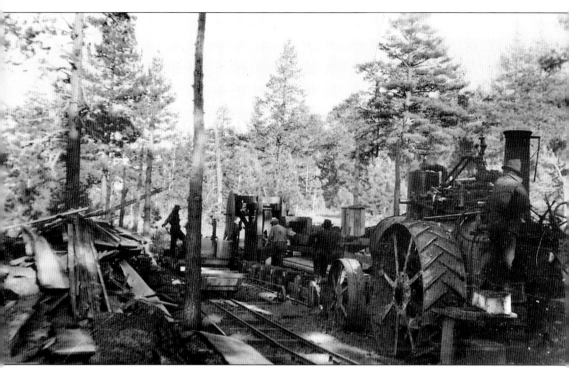

By the 1890s, many sawmills were run by steam traction engines, especially small operations located in the upper elevations where harvest was seasonal. These engines were used not only to power sawmills but also for transportation. Each spring, the traction engine would be driven to the desired location. The rest of the mill was pulled behind it on carts or hauled in by wagon. With the first snowfall of winter, the portable mill would be dismantled and hauled out. Pictured above is the Koenig Mill of Alpine County. This type of mill, known as a "ground hog," sat on raised blocks. It used a two-blade, over-and-under circular saw to cut larger diameter logs and produce rough-cut lumber. Narrow-gauge railroad tracks were temporarily laid to aid in skidding logs. (Courtesy Alpine County Museum.)

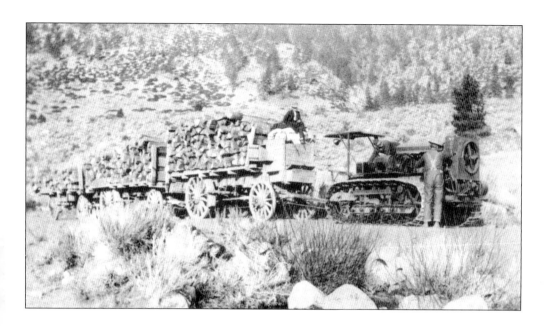

In 1904, Benjamin Holt of Stockton, California, tested a gasoline-powered machine that moved on self-laying tracks instead of wheels. He named this invention the Caterpillar. It ran on either kerosene or gasoline fuel and adapted well to soft, sandy soils and steep grades. "Caterpillar" soon became the generic name for all crawler tractors. Above, a caterpillar is hauling wagonloads of cordwood down to the Carson Valley. Below is a larger, newer model that was tented to shade the driver in the hot Nevada high desert. (Courtesy Alpine County Museum.)

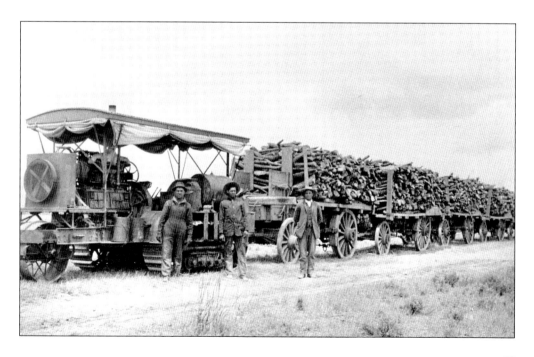

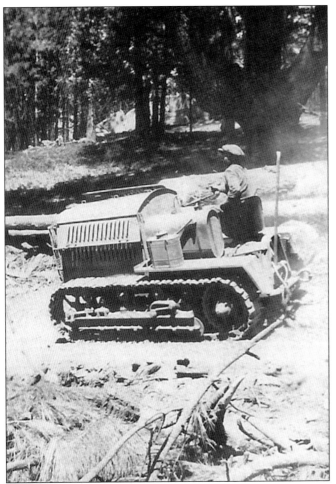

Many small logging operations in the Central Sierra found the caterpillar to be invaluable, used not only for transportation but also in the woods, where it was largely able to replace the steam donkey for skidding and yarding. The Berry Lumber Company was a father (Clarence) and sons operation in West Point, Calaveras County, in the early 1900s. As the company grew, it invested in a lightweight Cletrack crawler tractor that could easily be operated by one of the boys (left). Early tractor manufacturers used gasoline until the 1930s, when diesel fuel engines began dominating the industry. By 1928, the company was able to purchase this new D60 Cat, below, which young Ben Berry, age 22, proudly displays. Ben would later claim that it was "the Cat" that helped the company to grow so successfully. (Courtesy Ben Berry collection.)

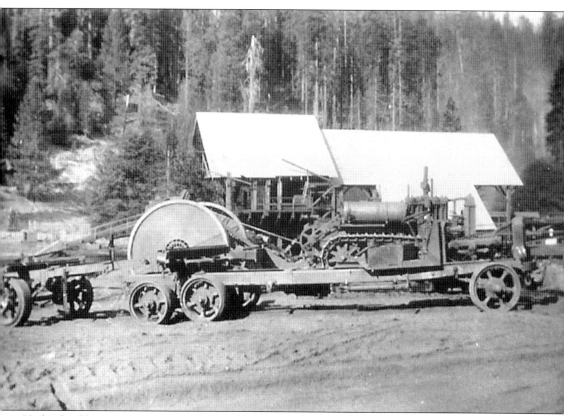

High-wheel logging, common to the sugar pine region of California, paired giant 12-foot-diameter wheels with a connecting axle and long tongue that was harnessed to a team of horses. The front end of a log was lifted off the ground with grapples attached to the high wheels. The log could then be dragged over rocks, brush, and stumps. By the 1920s, mechanized vehicles had replaced horse teams in pulling high wheels. Pictured above is the Berry Lumber Company's logging equipment assembled in 1925, consisting of a D60 Caterpillar, high wheels, a Model T hard-rubber-tire logging truck, and a hard-rubber-tire trailer. Rather than using horse teams, the D60 pulled the high wheels through the forest dragging logs. The Model T truck and trailer then delivered the logs to the mill. The adaptation of these four pieces of equipment made the Berry logging operation much more versatile in the woods. Most of the buildings and equipment pictured in the background were custom manufactured on-site, including the mill, carriage, and steam plant. (Courtesy Ben Berry collection.)

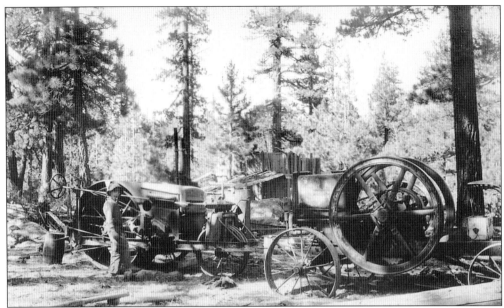

Small, family-owned, portable sawmills were also common in the Central Sierra. These mills, operated seasonally by two to four men, were easily relocated once a stand was harvested. The 1920s family-run Hellwrinkle Sawmill in Hope Valley, Alpine County, was a basic rough-cut lumber mill that operated during the summer months. This "groundhog mill" utilized a two-blade, over-and-under circular saw mounted on a framework. The mill ran on one long cylinder gasoline engine sitting on frame wheels. A case-iron hopper kept filled with water cooled the engine. Below, the Hellwrinkle utilized a three-wheeled gasoline-powered tractor. A fresh log sits on the carriage as the sawyer begins a new cut of rough lumber. Note the overhead cable line used to lift logs. The Model T coupe dates these photographs as mid-1920s. (Courtesy Alpine County Museum.)

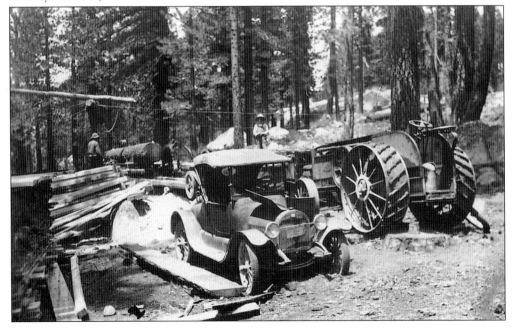

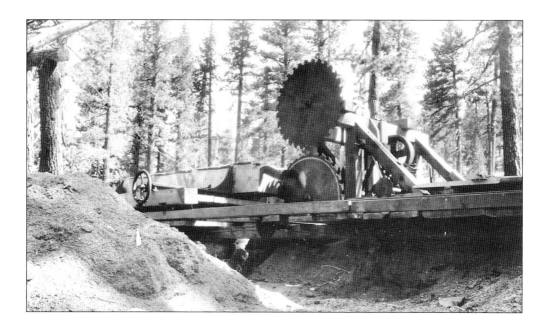

The above photograph of the Hellwrinkle provides an excellent aspect of the over-and-under circular saw blades. Logs sitting on the carriage were pushed through the saws to produce rough-cut lumber. Note how the framework is blocked up from the ground, lending the name "groundhog mill." Below the framework is a hand-shoveled pit that collected sawdust produced by the blades. When the pit filled up, it was shoveled out onto a pile. Loggers would sometimes light these sawdust piles on fire when the mill was disassembled in fall. The piles could easily smolder throughout winter and sometimes even for years. Spontaneous combustion could also be a problem, occasionally causing forest fires long after the mill was removed. The photograph below shows the drive belt and logs waiting on the log deck to be cut. (Courtesy Alpine County Museum.)

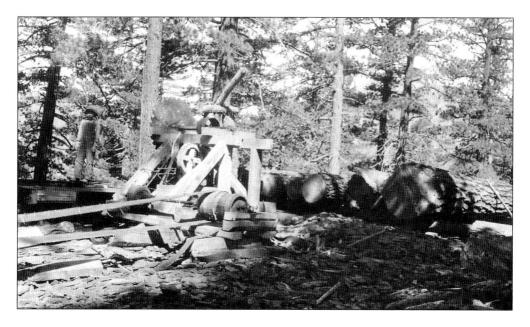

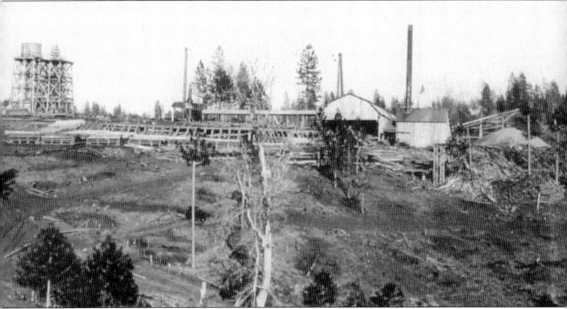

In 1911, millionaire logging industrialist/capitalist Charles Ruggles came to Amador County from Michigan to construct a steam-powered sawmill near Mace Meadows. The big production mill cut millions of board feet of lumber before it closed down in 1927 when merchantable timber ran out. From left to right, this panorama of Ruggles Sawmill in 1922 shows the camp housing, wooden water tanks sitting on wooden trestles, the steam-powered donkey engine used for yarding, the mill, boiler building, slab chain conveying waste, and sawdust and slash piles. In the foreground, stacks of stickered rough-cut lumber are air drying. The Ruggles Sawmill had the characteristically loud shotgun carriage jam with a long steam cylinder common to high-speed mills of the day. Early-20th-century mills were built close to timber at elevations of 2,000 to 6,000 feet. Any electricity used in the mill for lights and so forth was generated on-site. Charles Ruggles can be seen on page 87. (Courtesy Fred Thomas.)

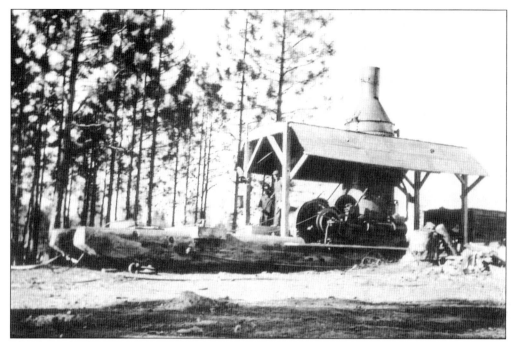

The above donkey engine was utilized at the Ruggles Sawmill for yarding. The more sophisticated 20th-century donkey engines were mounted on the backs of large sleds or skids built from logs. Once the skids rotted, a new pair was built. (Courtesy Oneto family.)

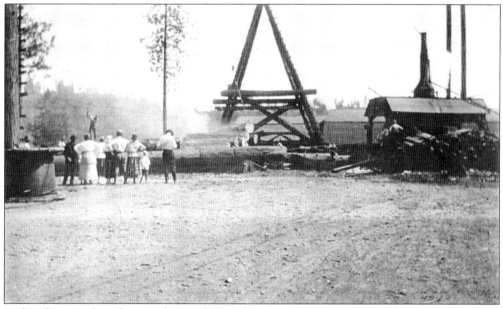

In this photograph, railcars are being off-loaded at the mill site. On the far left, a man can be seen standing on a log car. He is directing an A-frame with bridal hooks to lift logs. Note the cordwood piled in front of the donkey used to fire the boiler. (Courtesy Amador County Archives.)

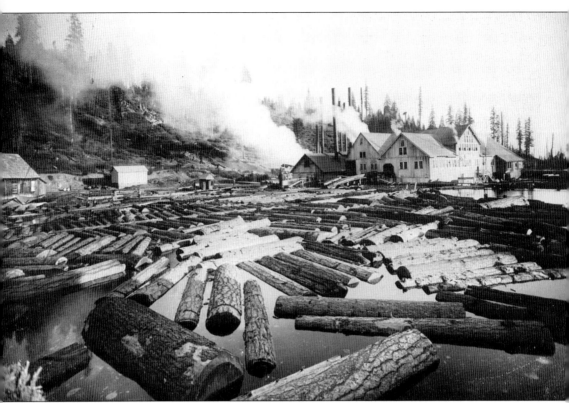

Shallow log ponds were essential to large-scale sawmill operations. Logs stored in ponds until they were milled were purposely kept wet to prevent cracking. The ponds also allowed logs to be easily maneuvered over to the mill on a selective basis. "Pond monkeys" were in charge of moving logs and breaking up jams. Renowned for their ability to balance themselves as they walked across the floating logs, these men wore "calk" (pronounced "cork") shoes with tapered nails fastened to their soles, which dug into the wood. A 16-foot-long pike pole, tipped with a spike or small hook, was used to sort logs. Pond monkeys, who habitually wore wool underwear to keep warm no matter how cold or wet they became, are credited with the old adage "easy as falling off a log." The jack ladder is seen in this photograph lifting logs into the mill. The logs were guided into position by the pond monkey, then caught by the jack ladder chain and pulled into the sawmill for cutting. (Courtesy Amador County Archives.)

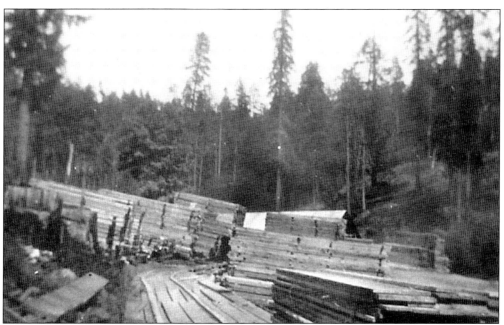

After lumber was cut, it would be stacked in drying yards. Above is the Berry Sawmill's lumberyard in West Point, Calaveras County, in 1922. Rough-cut lumber was transported to the yard on a tram and stacked according to size. Stickers were placed between the layers of wood for air circulation while drying. The weight of the stacks helped to keep the boards from warping. Once dry, the lumber was moved to the planing mill, where it was cut to its final dimensions and its surfaces smoothed and cleaned. The lumber was now marketable. In 1929, the Berry Lumber Company moved its operation to El Dorado County, where the business continued until the mid-1960s. The photograph below, taken at their new location, showed carefully stacked and stickered rough-cut lumber air drying in the yard. (Courtesy Ben Berry collection.)

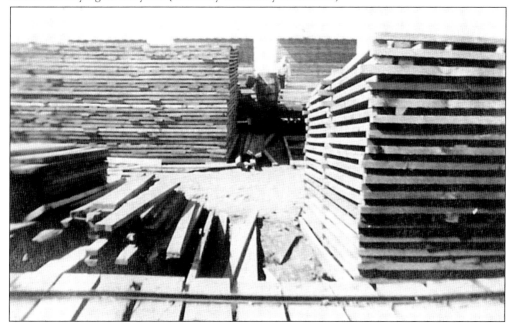

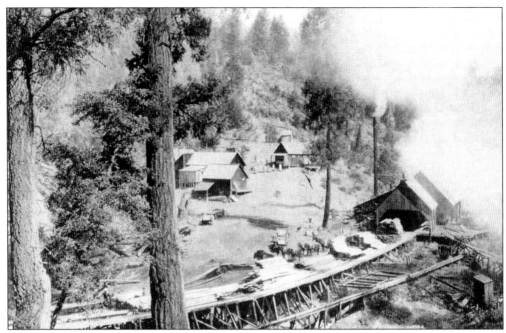

Above is a sawmill operated by the Pacific Gas and Electric Company in 1911. The company owned 3,580 acres of timber land in Nevada and Amador Counties. Two fully equipped sawmills cut sufficient lumber to make repairs to flumes in both the Nevada and Standard Divisions. The canals were often utilized to transport lumber. (Courtesy Carl Boitano.)

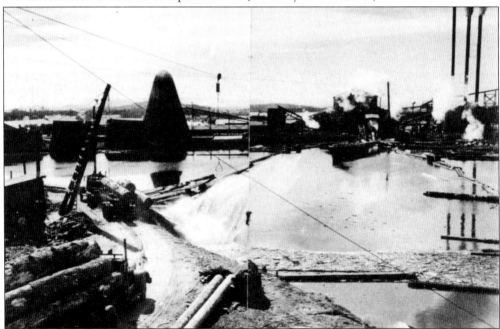

The Winton Sawmill was built in Martell, Amador County, in 1942. The Tee Pee waste burner was standard to most bigger mills until environmental laws in the 1960s outlawed their use. Winton Lumber Company sold several times over the years to American Forest Products, Bendix, Georgia Pacific, and finally Sierra Pacific Industries. The mill closed in 1997. (Courtesy Ross Oliveto.)

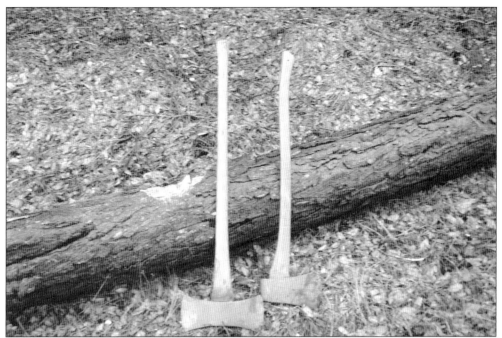

In the woods, the ax was a constant companion. Fallers spent hours putting a razor edge on their falling axes. To test their precision, they would sometimes attempt to drive a stake into the ground with a falling tree. Above, single- and double-blade axes are displayed. Below, a faller is using an ax to make an undercut. Americans had modified the European chopping technique of making V-shaped cuts at almost the same level on opposite sides of the trunk. Instead, they made one cut, considerably lower (the undercut) and made both cuts flat on the bottom. This method gave greater control over the direction of fall and reduced the use of wedges and levers. (Courtesy Fregulia family and Paul Bosse family.)

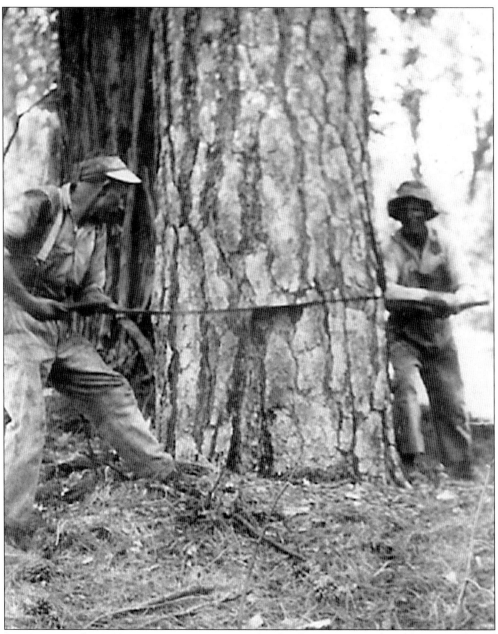

Beginning in the 1870s, crosscut saws, once used only after a tree was down, became adapted to felling. The development of tempered-steel blades with raker teeth yielded saws that would carry away sawdust, remained sharp through prolonged use, and were less apt to snap in two. The raker-toothed crosscut saws could save up to two-thirds the time formerly taken to fell a tree, and fallers had greater control over where the tree landed. By 1900, the crosscut saw had become the main felling tool, axes being relegated to the support role of making diagonal cuts. Above, these fallers are using a two-man "misery whip" to make the undercut on this ponderosa pine. Fallers always carried a bottle of kerosene to dribble on the cross-cut saw blades to prevent pitch from binding them. This photograph was taken in the fall of 1928 near Glencoe, Calaveras County. (Courtesy Diane Aksland Adams.)

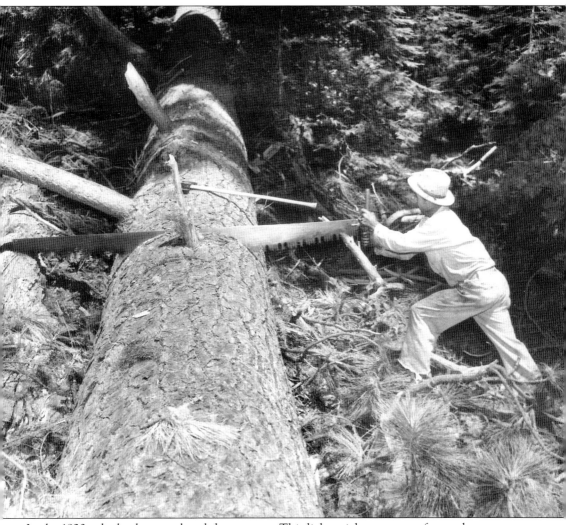

In the 1920s, the bucksaw replaced the crosscut. This lightweight saw cut as fast as the crosscut, was easier to carry, and could be used close to the ground. Once felled, a tree was limbed and bucked (cut to length), generally in 24-, 32-, and 40-foot lengths, the standards for sawmills. Bucking was one of the most dangerous jobs in the woods. Bucked logs easily rolled over when released from the rest of the tree, crushing the workers. Flying limbs from falling trees also injured many men. Originally buckers worked in pairs, pulling and pushing the long bucksaw through the log. Later it became possible, with improved saws, for buckers to work alone. Above, Fred Olivera is bucking a downed tree using a single-man bucksaw. He won the "bucking" contest at the Amador County Fair. (Courtesy Ben Berry collection.)

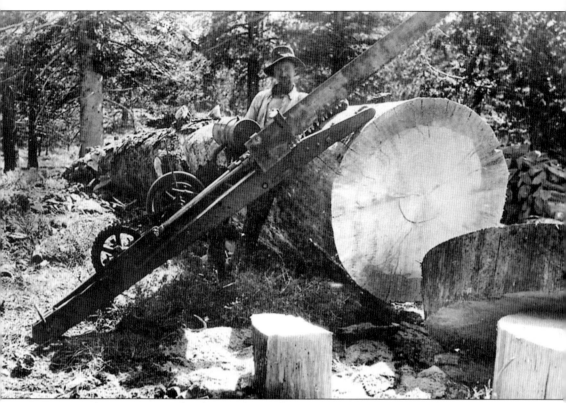

Inventors began trying to develop mechanically powered saws with the first gasoline chain saw tested in Eureka, California, in 1905. Other experimental saws included those powered by portable air compressors and electric generators. Mechanically powered circular saws, reciprocating "drag" saws, and chain saws were tried both for felling and for bucking, but these early devices were heavy, undependable, and very hard to lug through the forest. Pictured here, Herman Trottles of Alpine County displays his one-cylinder, water-cooled, gasoline-driven drag saw, mounted on a wooden frame. This portable saw had a crosscut blade used for bucking logs to length once the tree was felled. Drag saws were the interim between crosscut and the chain saw. This downed tree shows the distinctive "blue stain" of fungal deterioration. It was not lumber-grade wood. Instead, Trottles was cutting "lily pads" or block wood that was then split into cordwood. (Courtesy Alpine County Museum.)

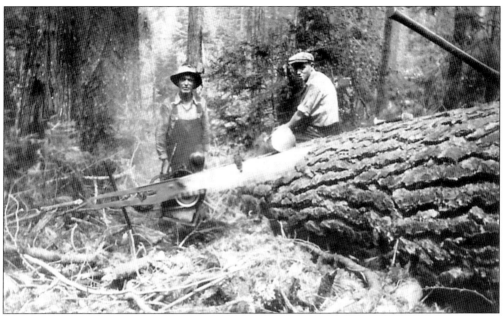

The Berry Lumber Company employed fallers and equipped them with early-model chain saws. According to Ben Berry, "The first chainsaws weren't as advanced as they are today." Chain saws were "large, two man affairs." But they "quickly advanced to become the fastest way to cut lumber." The portable, gasoline-powered chain saw was a great breakthrough, saving loggers time, eliminating much of the earlier ax work, and allowing for improved felling techniques. The above photograph was taken during the summer of 1930. Below, a later-model two-man "Mall" chain saw with 8-foot bar is operated by Mr. Hoagley (left) and his son-in-law, Ralph McKenzie (right), around 1950. As chain saws became more refined after World War II, they replaced the crosscut as the main felling tool of loggers. (Courtesy Ben Berry collection.)

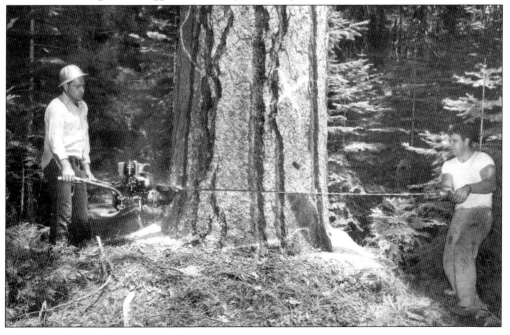

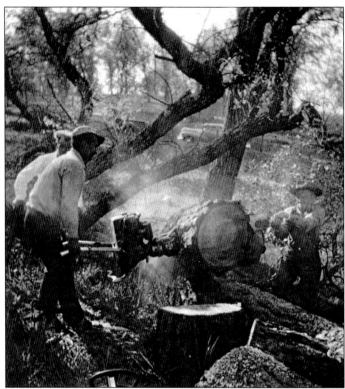

Pictured here is an early two-man Mall chain saw being used to cut up cordwood in the late 1940s on the Laughton Ranch near Jackson. Alex Laughton and his father, Dudley, are operating the saw, while Archie Wilson waits to lend a hand. (Courtesy James Laughton.)

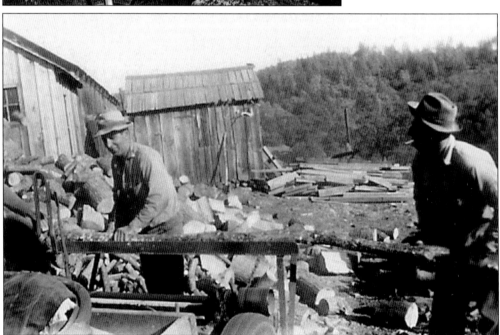

During the early 1900s, families often assembled homemade mills to cut cordwood for home consumption. Pictured here, the Fregulia brothers—Henry on the left and Jim on the right—are operating a buzz saw mounted on a pickup truck frame. The bed was removed so that the saw could be attached to the frame and driven by the truck's tires. (Courtesy Fregulia collection.)

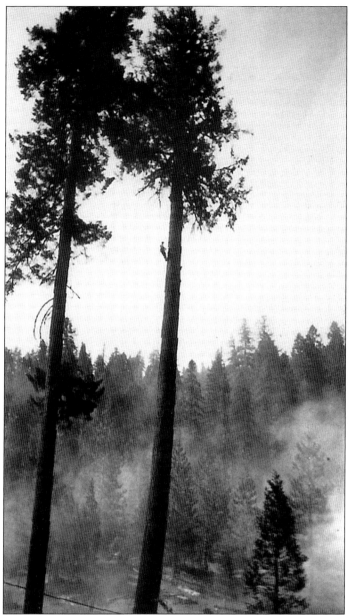

The method of high-lead logging developed in the early 1900s as a means of yarding. One or more spar trees were rigged with high-lead blocks. A 1.5-inch hauling cable was run from a donkey drum on the ground, up through the high-lead block, and out to the timber. Once a log was hooked up, the donkey would pull the line, lifting the nose of the log over obstructions or suspending it in midair. Spar trees were chosen for their height, straightness, sturdiness, and scarcity of branches. Usually 6 to 8 feet through at the butt, and 250 feet in height, spars were topped, trimmed of all limbs, and then rigged. High-lead logging eliminated the wasteful and expensive ground-lead system and the hang-ups when logs were pulled flat across the ground. It was especially adapted to logging uphill, giving a lift to the logs, particularly in clear-cut areas. Logs could also be transported over wide, deep canyons from one hill to another. Above, Frank Berry is scaling a chosen spar tree in 1929. (Courtesy Ben Berry collection.)

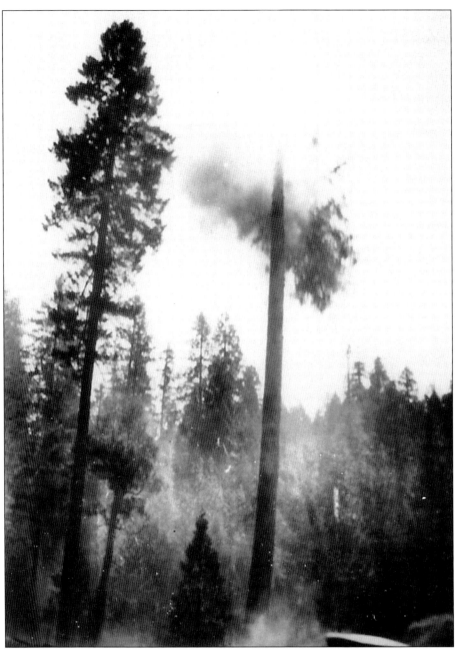

The work of preparing a spar tree was done by high-riggers like Frank Berry. The high-rigger climbed by stepping up the tree using a rope passed around the trunk. He would lop off each limb as he climbed using his one-man saw and topper's axe. At about 200 feet above the ground, the high-rigger would remove the top of the tree. Frank Berry's chosen method to accomplish this was to fix dynamite to the trunk, scurry back down the tree, and then set off the blast. Above, the top of the spar tree is being blasted off. Once the tree was de-limbed and de-topped, Frank would once again climb the spar to set the high-lead rigging. It usually took two to three days to rig a spar tree. The high-rigger's job was considered one of the most dangerous jobs in the woods. Berry learned this skill while working as a lumberman in Oregon. (Courtesy Ben Berry collection.)

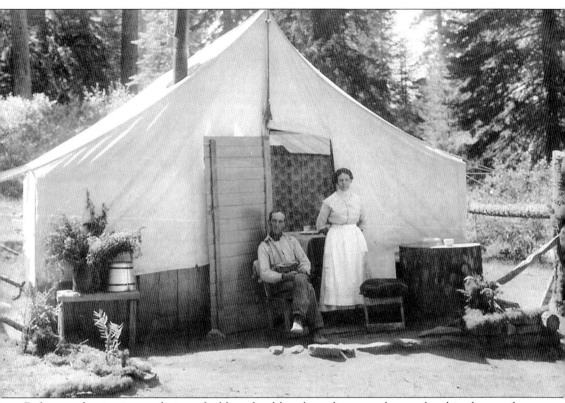

Before mechanization made it profitable to haul logs long distances, loggers lived in the woods near the timber site to be harvested or at the sawmill where the logs were processed. Those who worked in the logging industry were often transient, moving from one location to another, dependent upon the seasons and employment available. Sometimes their wives and children accompanied them. Pictured above are Will Smith and his wife, Alice Ludekins Smith, of Pine Grove, Amador County. Alice took great pains to make their summer home, a tent cabin, as comfortable as possible. The wainscot sidewalls were usually made from local materials. When the logging camp disassembled, the canvas was folded up, but the wooden walls and flooring were often left to rot. Seasonal tent cabins were typical to logging camps in the early 1900s. (Courtesy Ben Berry collection.)

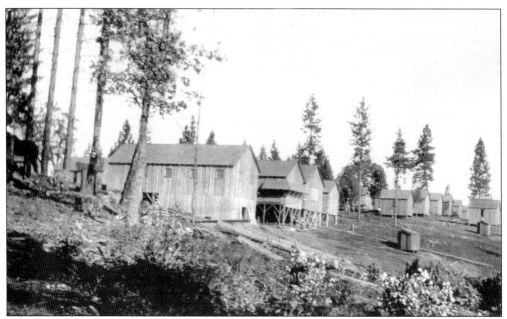

Many permanent, upper-elevation sawmills provided housing for the loggers. Above, the Ruggles Sawmill camp housing consisted of four-to-six-man bunkhouses, cookhouse, company store, and utility room or blacksmith's shop, where saws and tools were sharpened. After a long day of work, the loggers would eat, spend an hour or two playing cards in a kerosene-lit room, then fall into a deep sleep. (Courtesy Amador County Archives.)

In the 1940s, the Berry Lumber Company erected 30 framed cabins for the owners, employees, and their families. According to Ben Berry, "After the war, we had 120 people working at the camp. We ran buses from Jackson to our mill. Some families lived there, some boarded there, and others commuted. We never had a store—most families bought their groceries in town—but we did have a school and a kitchen." (Courtesy Amador County Archives.)

Five
Logging Trucks

Manufacturers believed that the gasoline-powered combustion engine could be utilized for transportation in the logging industry. However, motor-driven commercial vehicles had fierce competition in the early 1900s. Railroads transported lumber cross-country in 10 days, and most towns were served by railheads. Where railroads were not available, steam-power traction engines could be utilized for long hauls and draught animals for short ones. There seemed to be no apparent need for motor trucks, especially in logging.

Another obstacle faced by this new industry was the lack of decent roads. Not only did early truck manufacturers have to gain acceptance for their products, but they also had to design systems and components that could be operated on bare ground.

A limited number of gasoline-fueled logging trucks were in the forest by 1913, but their load capacity was small. The long beds and narrow, solid rubber or steel tires characteristic of these early trucks could not operate on steep grades and rough roads. Rather, these logging trucks were run on plank roads made of rough-hewn lumber. The treadless tires made travel on frost-covered or wet surfaces treacherous.

It was the technologies introduced with World War I that are credited with the success of the logging truck. The tremendous demand to move huge volumes of war supplies, troops, and food could not be met by the nation's railroads. It fell upon trucks and a good system of highways to ease the pressure. The newly developed macadam road surface allowed for heavy vehicle travel during this crucial time. By the end of the war, the motor truck was firmly established as a viable means of transportation, and these innovations made their way to the forests.

Soon the logging industry saw a reemergence of small-scale outfits. Up until that time, only large lumber companies could afford the high cost of stumpage and expend the capital needed for costly railroad equipment. After World War I, there was a surplus of military equipment. Trucks that could be used for hauling logs had become affordable for the small operator. A new era in logging had begun.

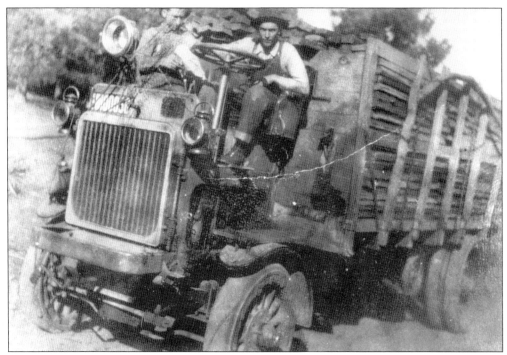

Few trucks were used by logging companies until after World War I, when surplus military equipment became affordable. Charles T. Jeffrey of Kenosha, Wisconsin, designed the Nash-Quad truck in 1917 for the war. It was a chain drive, two-axle, 5-ton truck with hard rubber tires and wooden spoke wheels. Pictured above, Henry Smallfield of Jackson is driving his Nash-Quad loaded with lumber. Enrico "John Dix" Cuneo is his passenger. (Courtesy Fred Thomas.)

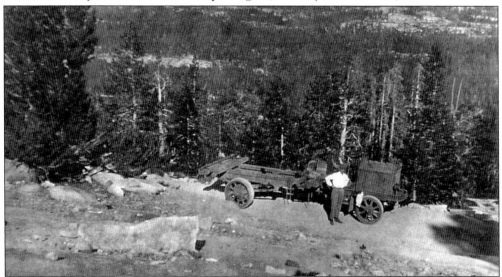

The above Fageol is climbing out of the Silver Lake Basin, Amador County, around 1920. This truck had planks laid lengthwise across its bed. Lumber bunks were then bolted to the frame. Restraining lines running from snubbing drums were used to brake down steep grades. This truck was capable of carrying short-length logs or lumber and was most likely owned by a small operator. (Courtesy Fred Thomas.)

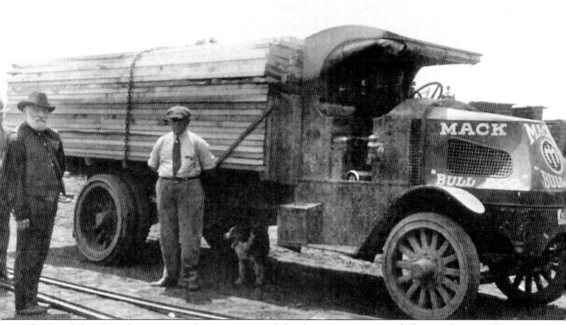

The Mack brothers began manufacturing one of the first American-made heavy-duty trucks in the early 1900s in Allentown, Pennsylvania. The business was sold to the International Motor Company, a holding company, in 1911, but continued manufacturing under the name Mack Trucks. During World War I, the truck earned an unparalleled reputation for reliability and durability. The company trademark, the Bulldog, originated as a nickname during World War I when the British government purchased the Mack AC Model to supply its front lines. British soldiers dubbed the truck the "Bulldog Mack" because of its pugnacious, blunt-nosed hood. Shortly after the war, Charles Ruggles purchased the Bulldog Mack seen here for his mill at Mace Meadows. Pictured are Mr. Rademaker (company secretary), Charles Ruggles, and Joe Wrightman (driver). (Courtesy Fred Thomas.)

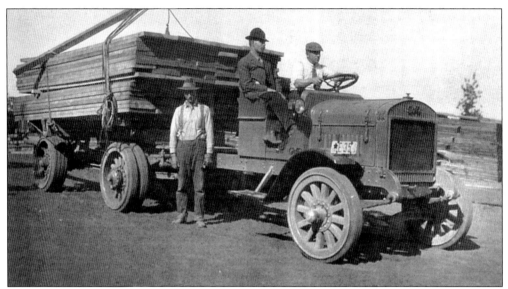

Ruggles realized that the success of his California venture depended upon adequate transportation. Adding to his fleet at every opportunity, Ruggles purchased this GMC to deliver lumber. In the above photograph, Robert Reed is standing next to the truck, Joe Wrightman poses in the driver's seat, and the passenger is unidentified. (Courtesy Fred Thomas.)

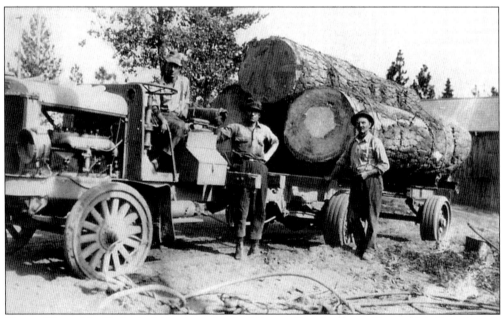

Pictured here, Mr. Godat is delivering a load of pine to Ruggles Sawmill using his Fageol truck with a trailer. The trailer had a pivot bunk on the back frame. Logs were chained to both the front axle and the rear disconnect axle, serving as the only connection between the two. As the only brakes were on the front axle, drivers drove very slowly downhill. (Courtesy Fred Thomas.)

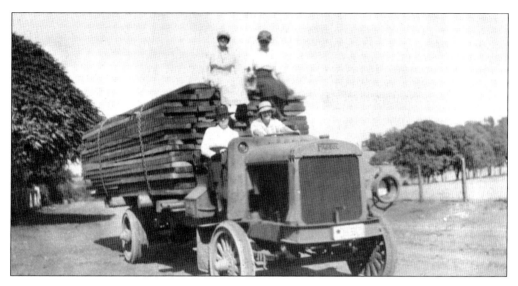

One of the most popular logging trucks in the Central Sierra was manufactured by the Fageol Truck and Coach Company of Oakland, California. The Fageol, first built in 1916, was sturdy, dependable, and easily recognizable. The name, "Fageol," was embossed in large letters on the radiator shell, and a series of louvered vents on top of the engine hood made them distinctive. Above, a Fageol loaded with milled lumber is proudly displayed by the womenfolk of Jackson Valley. Below, a load of debarked logs harvested near Volcano was loaded on the Grillo brothers' Fageol to be delivered to the mines in Sutter Creek. (Above, courtesy Amador County Archives; below, courtesy Ross Oliveto.)

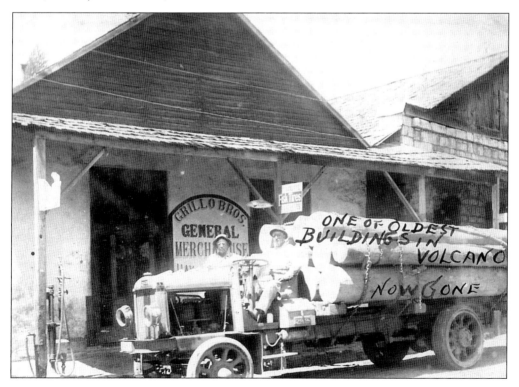

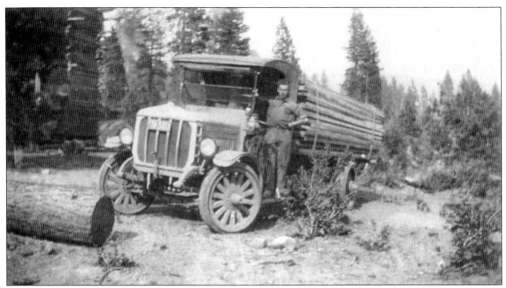

Above, a post–World War I C-cab is hauling a load of rough-sawn lumber in Amador County high country. (Courtesy Fred Thomas.)

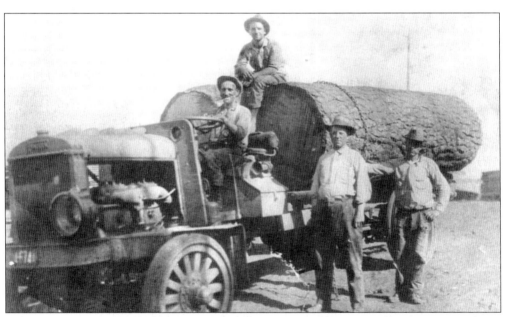

Dave Oneto, who for years delivered logs to the mines with his 12-mule team, invested in a Fageol in the early 1920s (see page 17). By this time, logging roads were being built throughout the Central Sierra. Oneto is shown here driving the Fageol; Kirk Boitano is seated on the logs. Mr. McPherson (left) and Emmet "Gabbie" Garbarini (right, no relation to the Garbarini family of Jackson) are standing. (Courtesy Marie Oneto Martin.)

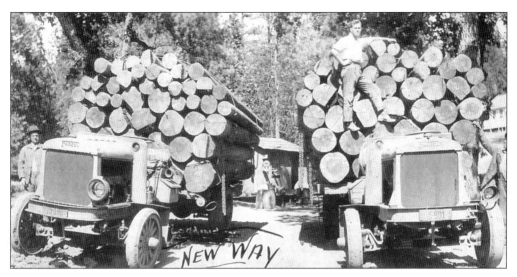

During the 1920s and 1930s, significant advances in power and design increased the logging truck's usefulness in the woods. More horsepower allowed for the transport of heavier loads. Better braking systems made the vehicles safer on steep grades. Above, a couple of Fageol trucks are labeled a "new way" of logging in Amador County. In the later years, the Fageol boasted an aluminum grille in front of its radiator and a cab with smooth, rounded corners. Wider, inflated, pneumatic treaded tires permitted travel on graded dirt roads. These trucks were driven by Nick Oneto, left, and Lawrence Molfino. Below, the Fageol truck owned by Angelo and Andrew Piccardo was purchased in 1928. It had air brakes with steel drums and brake lining, a worm drive rear end, and a four-speed transmission. Their brother-in-law, Colombo Casassa, drove the vehicle. (Above, courtesy Ross Oliveto; below, courtesy Piccardo family.)

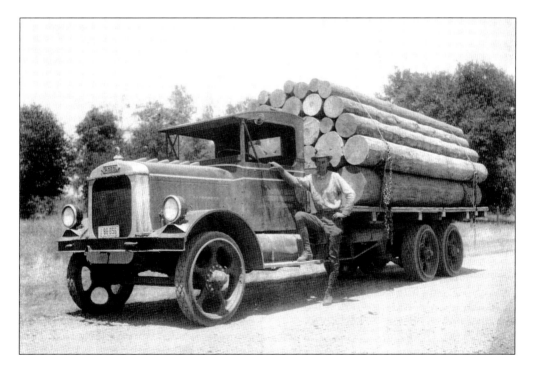

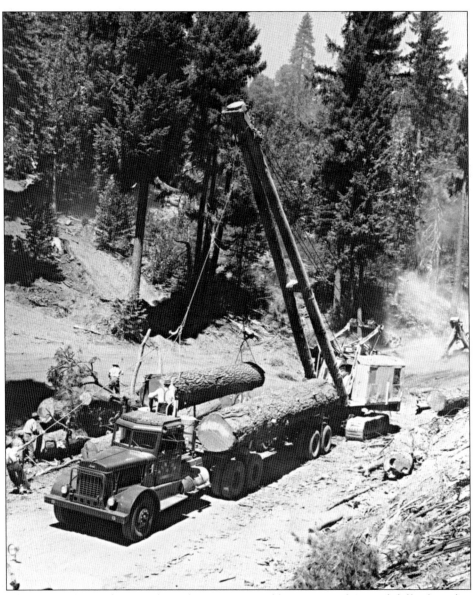

Despite its popularity, the Fageol Truck Company could not escape financial difficulties during the Great Depression. The company was forced to close down production in 1938. T. A. Peterman, a logger and plywood manufacturer in Tacoma, Washington, purchased the Fageol that year to build customized chain-drive logging trucks. The first vehicle off the assembly line was named "Peterbilt." Concentrating on quality, rather than quantity, the company produced less than 100 trucks per year. Peterman was able to secure government contracts during the war, and the engineering and production expertise gained allowed Peterbilt to become a top commercial producer. By then, the Peterbilt was considered the best truck in the industry. After Peterman's death in 1945, the company's assets were sold to management employees who were determined to preserve the company. In 1958, Pacific Care and Foundry, who owned Kenworth, purchased the company. Peterbilt trucks continued to be built in the Oakland facility until 1960, when production was moved to Newark, California. Above, a Peterbilt is being loaded by a wooden A-frame boom around 1939. (Courtesy Amador County Archives.)

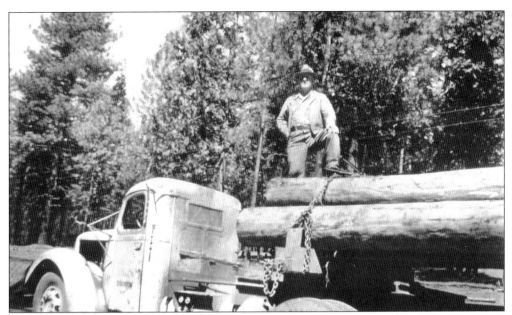

Frank Boskovich is standing on his loaded International around 1948. This truck was run on butane as indicated by the gauges on the gas tank. The sides of the hood had been removed to allow for air flow over the engine. Frank was pulling a two-axle trailer. (Courtesy Banicevich family.)

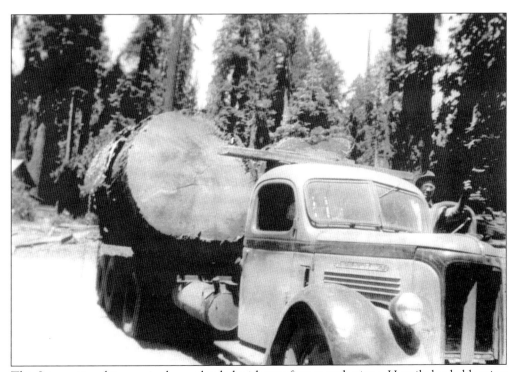

This International is seemingly overloaded with two first-growth pines. Heavily loaded logging trucks were often difficult to control on downhill slopes. Many times, a driver was forced to jump from a truck when it was "lost" on a steep Sierra grade. (Courtesy Amador County Archives.)

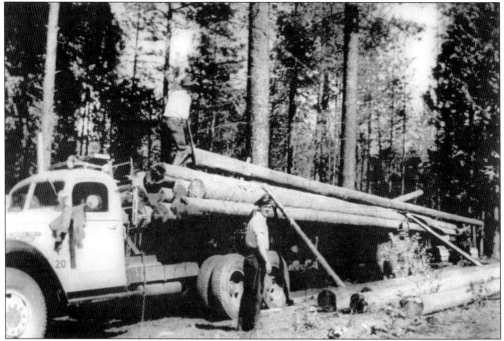
The man standing on top of the trailer is using a cant hook to unload lodge pole pines off this Dodge truck. Adolph Galli is standing next to the truck. This straight pine was the typical species used for utility poles. (Courtesy Fregulia collection.)

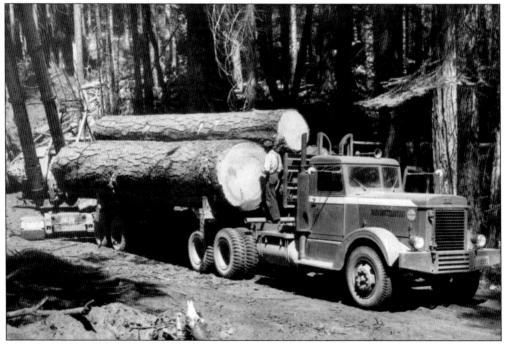
This Peterbilt would also be considered overloaded by today's standards. Because the width of this load was over 8 feet, the logs were held in place by cheese blocks, chains, and binders rather than by stakes inserted in pockets on the edge of the trailer. (Courtesy Ben Berry collection.)

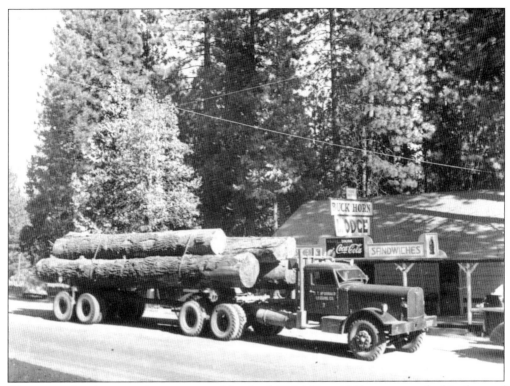

Above is a diesel engine Autocar owned by the J. T. McDonald Company parked in front of Buckhorn Lodge on Highway 88 in Amador County. Although engine manufacturers began experimenting with diesel engines after World War I, they were not successful in selling them to American truckers until the early 1930s. By 1940, diesel engines had largely replaced gasoline engines in both trucks and tractors. (Courtesy Amador County Archives.)

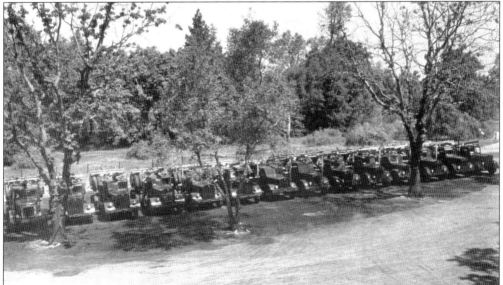

The J. T. McDonald Company was purchased by the Winton Lumber Company in 1948. Winton acquired the fleet of 14 logging trucks pictured above. (Courtesy of Jim Laughton.)

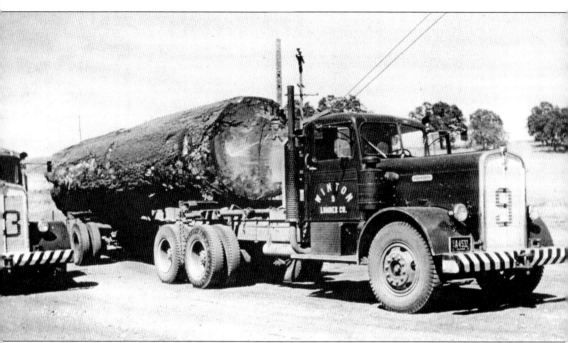

Within a few years, Winton had changed their fleet to Kenworth. The Kenworth Motor Truck Company, formed in 1923 in Seattle, Washington, was named for its two principal stockholders, Harry Kent and Edgar Worthington. Specializing in the "custom truck," their vehicles were built to customer specifications after orders were placed. The company's average production within two years was two vehicles per week. Kenworth experienced continued growth throughout the 1920s, opening a larger facility in Seattle and a manufacturing plant in Canada. However, the Great Depression took its toll. To combat this, Kenworth became the first American truck manufacturer to install diesel engines as standard equipment. The diesel engine allowed Kenworth to develop a powerful and durable line of diesel trucks. Customers were pleased, especially since diesel was a third of the price of gasoline. With the passage of the Motor Carrier Act in 1935, new regulations meant stiffer weight and size restrictions. Kenworth engineers developed aluminum components, including hubs and cabs. Kenworth trucks also featured six-wheel drive, hydraulic brakes, four-spring suspension, and rear-axle torsion-bar suspension. (Courtesy Jim Laughton.)

Alex Laughton, seated, is pictured above with his visiting brother, Dudley. Laughton was a driver from Winton Lumber Company, assigned to Truck No. 3 of the 14-truck fleet. Each truck was assigned to an individual driver. The starting times every morning were staggered—the first shift out began at 3:00 a.m., the last out at 7:00 a.m. The trucks would then arrive at the logging site at timed intervals. The drivers would work 12 to 14 hours, transporting up to three loads a day to the sawmill. Pictured below is the Winton Lumber Company's Kenworth fleet. (Courtesy Jim Laughton.)

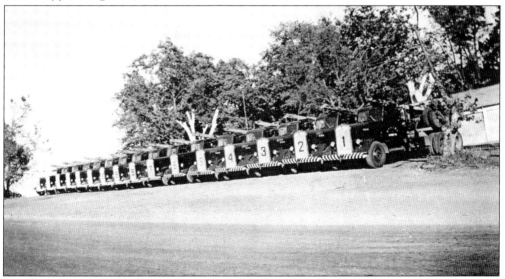

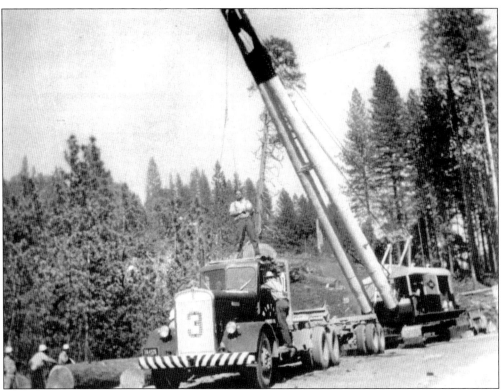

This photograph was taken near Blue Mountain, Calaveras County, on Winton Lumber Company land. Coleman Rader, the top loader, is standing on the truck cab directing the wooden double-mast A-frame crane. The crane, used to transport and load logs, lifted one end of a log up off the ground to drag it or suspend it in the air. (Courtesy Jim Laughton.)

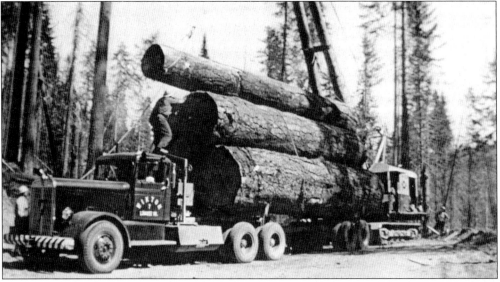

The truck shown above was being heavy loaded for a promotional photograph for the *American Eagle* magazine. No. 7 of the Winton fleet, driven by Ernie Harmon, was equipped with cheese blocks for hauling logs and also had the capacity to pull a lowboy trailer. (Courtesy Jim Laughton.)

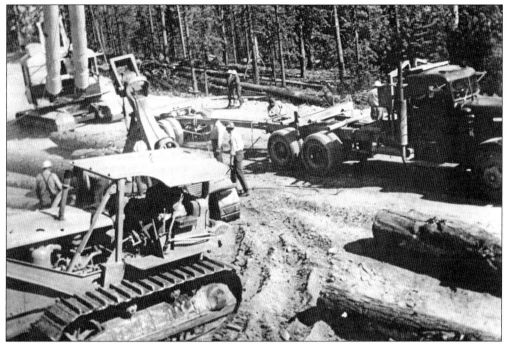

A Winton truck awaits loading at a landing. The logs were dragged there by the skidding arch pulled by the dozer. This wooden A-frame boom will now be used for loading. As shown in the photograph below, loading a truck was an 8- to 10-man operation. (Courtesy Jim Laughton.)

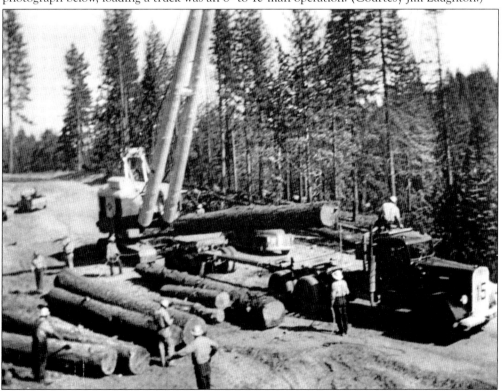

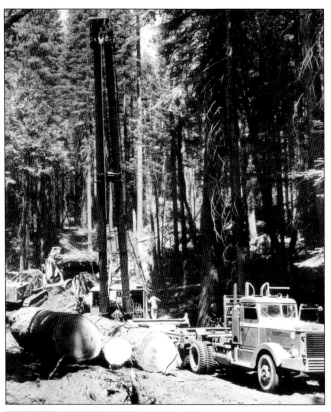

At left, logs are about to be loaded with a Lima loader onto Budd Fines's Peterbilt truck for delivery to the Berry Lumber Company. The wooden double-mast A-frame crane had several advantages. It was easily dismantled and moved from site to site. It could also be refitted with new log arms if the old ones were to go bad. Unfortunately, the logs or wooden poles would occasionally break, sometimes injuring loggers. Fines's truck was capable of carrying a load of 13,000 board feet. Pictured below, standing on the landing, are loaders Dave Eggenhoff and Don Murphy. During World War II, tires were so scarce that discarded tires were cut open and slipped over a tire in need of a recap. It was held on by chains and fastened through the rim. (Courtesy Ben Berry collection.)

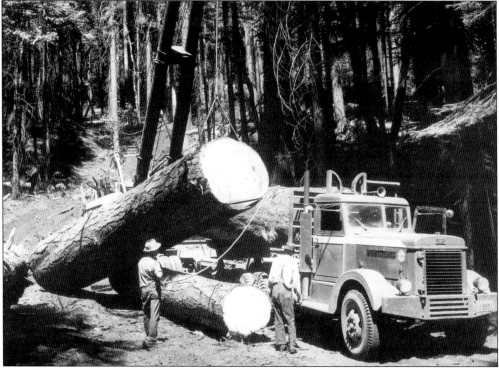

Six

The Berry Lumber Company

The Berry Lumber Company dominated the industry in Calaveras, Amador, and El Dorado Counties for many years. This family-owned venture was founded by Clarence Berry and operated by him, his wife, Susan, and five sons—Earl, George, Frank, Ben, and Ted—for nearly 50 years. From humble beginnings, it developed into a multimillion-dollar corporation and the only logging outfit of any consequence in the area. Its evolution is testimony to the family's hard work, perseverance, and devotion and provides a wonderful history of lumbering during the 20th century.

Clarence Berry and his young family were living in Glencoe, Calaveras County, in 1910. Among his various employments, Clarence owned a large apple orchard that provided a windfall each autumn. Unfortunately, it was difficult to obtain apple crates for shipping his produce, so Clarence assembled a small sawmill to manufacture his own crates. Soon locals were calling upon him for their specific lumber needs. The mill quickly turned into a profitable, albeit seasonal, business, supplying lumber to West Point and the Glencoe area. Within a decade, Clarence was shipping to Mokelumne Hill and Valley Springs and filling orders for Pacific Gas and Electric and the Mokelumne Hill Ditch Company. In order to continue operating during the winter months, the family opened a lumberyard in Valley Springs.

As Clarence's sons matured, each became involved in the expanding business. His wife, Susan, took charge of the Valley Springs Lumberyard. In 1929, the sawmill was moved into PiPi Valley, just north of the Amador/El Dorado County line. Here the company weathered the Great Depression, rebuilt after a disastrous fire, and incorporated. The demand for lumber after World War II proved so profitable that Berry became the largest employer in the region, providing up to 120 jobs each season.

By 1960, the sawmill's equipment was antiquated and government regulations for logging public lands became more stringent. An economic recession loomed. The Berry brothers, now aged, decided it was time to retire. They sold their holdings and dismantled the sawmill, and an era came to an end.

Except as otherwise noted, the photographs in this chapter were provided by the Ben Berry collection.

Clarence Allison Berry was born in San Joaquin County on February 23, 1869, the oldest of eight children. Shortly after his birth, his parents moved to Glencoe, Calaveras County, where his father, George Washington Berry, operated a mercantile. After George's unexpected death in 1896, the financial care of Clarence's mother and younger siblings fell upon him. In 1895, Clarence married Susan Fairchild, and during the next 20 years, the couple had eight children, five sons and three daughters. To support the family, Clarence entered into a number of ventures. Employed as a miner in the Glencoe area, he became superintendent of the Glencoe Mining and Milling Company and eventually purchased several mining claims that he worked well into the 1930s. Clarence operated a ranch, leasing property to run his cattle. Starting a sawmill to build apple crates to ship produce was secondary to his various occupations. Young Clarence Berry is pictured here at age 15.

Shown at right is Susan Fairchild Berry with her young sons, Earl and baby George. This photograph was taken in August 1899, in Glencoe. Below are the children of Clarence and Susan Berry. Pictured from left to right are Ruth; baby Esther; Earl; George; who is standing behind Ben; and Frank. This photograph was taken in 1910 before the births of Ted and Elizabeth. By this time, Clarence's oldest son, Earl, was working with his father in the fledging sawmill.

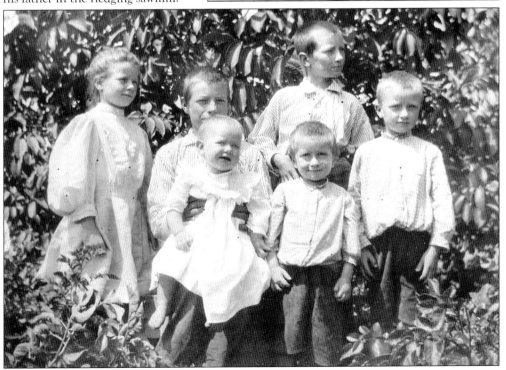

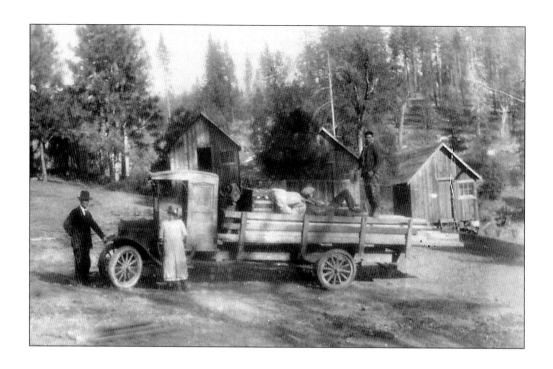

Clarence Berry's sawmill grew slowly, but with time, the father and his sons became more invested in it as their primary occupation. Above, the Berry family vehicle was photographed in front of loggers' cabins at the mill. No doubt this vehicle was used not only for family transportation, but also to haul milled lumber to Clarence's various customers. Below, Clarence and Susan's youngest children, Ted and Elizabeth, play in the log pond at the West Point mill around 1918.

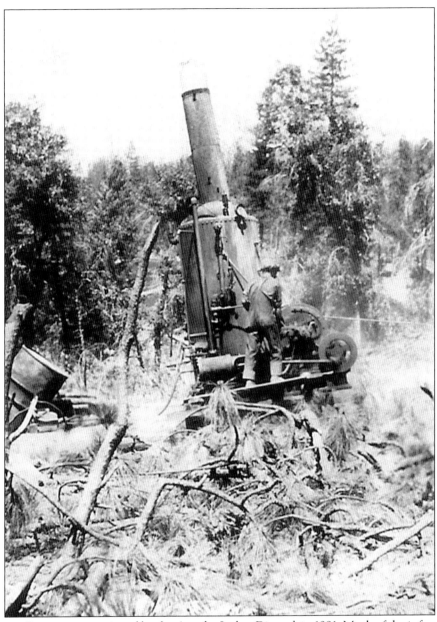

Benjamin Berry was interviewed by the *Amador Ledger Dispatch* in 1991. Much of the information provided below came from that interview. Ben left school at age 14 to work with his father and older brothers—Earl, Frank, and George—at the family mill in West Point. His first job was "whistle punk." The Berrys used a single-drum, vertical-skidding steam donkey with a high lead. Cable was wound up on these drums in order to drag logs through the wood. The hook tender would tell the whistle punk what signals to give, and the whistle punk, using a steam whistle, would signal the donkey jammer. After a year, Ben graduated from whistle punk to "firin' the donkey," keeping the donkey's boiler stoked with firewood. Next he moved to donkey jammer, whose job was to control the cable and yardarm that dragged logs from where they were felled. "I was more or less of a flunkie—did every job that there was to do." Ben is pictured above working on the donkey engine around 1920.

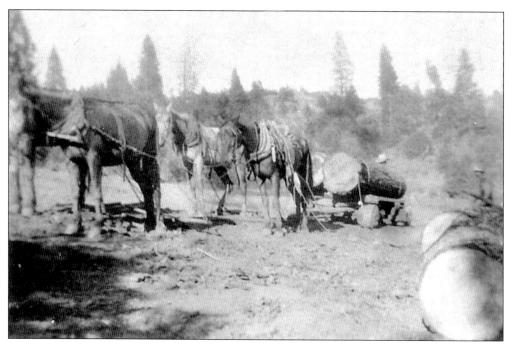

The proper yarding of large logs in Berry's sawmill was not always easy. In the early years, the family employed both a four-horse team and a Fordson tractor for this purpose. The Fordson was Henry Ford's first attempt to build tractors for the expanding market. In the two photographs, a little more "horse power" was needed to pull the heavy load up the hill. Take note of the wooden wheels or "lily pads" on the cart. These photographs were taken at the West Point sawmill in 1921. The timber had been harvested locally. (Courtesy Diane Aksland Adams.)

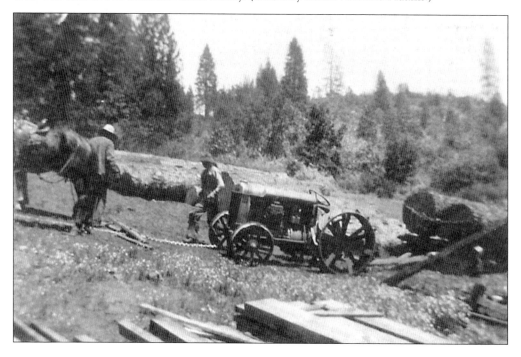

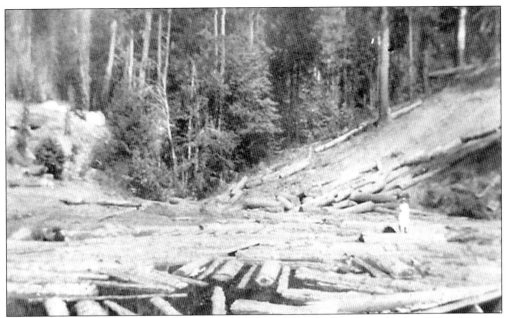

This photograph, taken in July 1922, shows a log pond dam built at the base of a drainage to retain logs skidded down the hillside. As the Berry milling operations could only operate seasonally, the family had to take full advantage of summer. Susan Berry is standing at the far right, giving dimension to the size of the timber being harvested at that time. (Courtesy of Diane Aksland Adams.)

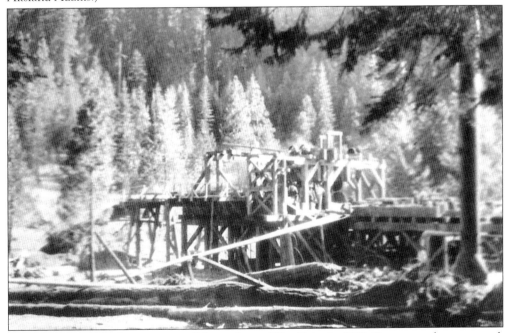

Pictured above is the Berry camp mill located near West Point in 1928. Constructed near a stand, the mill was not enclosed. Logs were pulled up the jack chain from the dry deck on the far left of the photograph, placed on the log carriage, and passed through two circular saws blades. The men standing near the blades give dimension to the mill size.

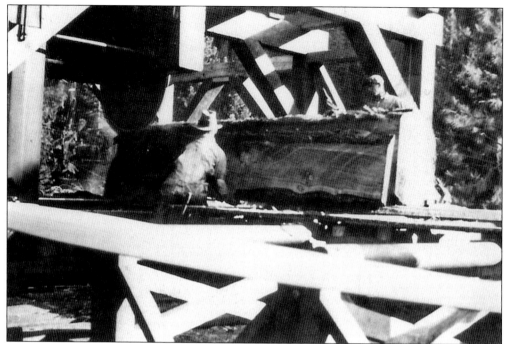

The Berry boys are shown here slabbing a log to make square-cut timber using an over-and-under 6-foot-diameter circular saw. The sawyer operates the carriage, while the off-bearer manipulates the log into the saw. The timber will be transported to the main sawmill, where it will be cut into dimensional lumber and finished.

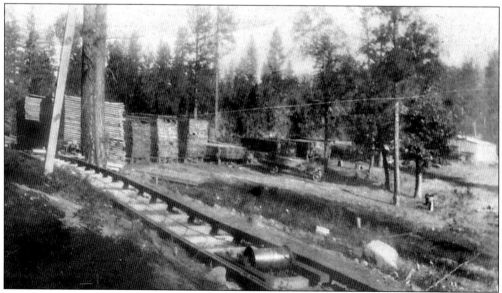

Once milled, the dimensional rough-cut lumber was stacked with stickers to air dry in the lumberyard. The lumber was hauled out to the yard with a cable-guide lumber tram pulled by a winch. A log truck sits near the end stack. (Courtesy of Diane Aksland Adams.)

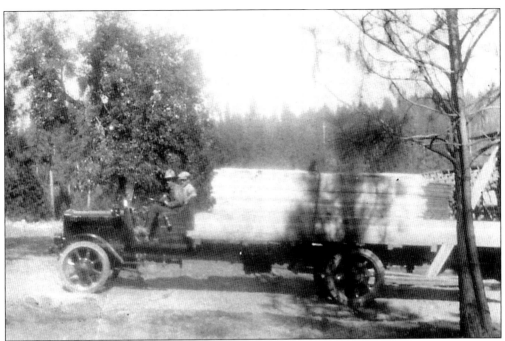

Clarence now could afford a Fageol capable of carrying larger loads. Here Clarence's sons George and Frank are leaving the yard to deliver a load of lumber. (Courtesy of Diane Aksland Adams.)

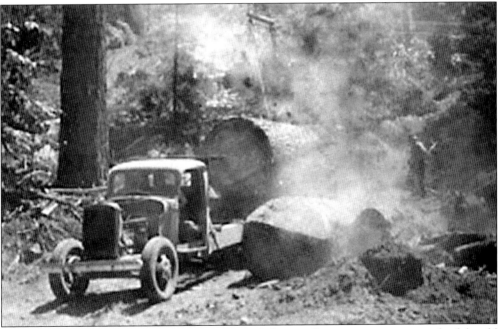

Because the region around West Point in eastern Calaveras County was remote, much of the old growth had not been harvested during the years following the Gold Rush. The Berry family was able to get into this rugged terrain with their modern equipment. Above, a log is being loaded on their truck. (Courtesy Paul Bosse family.)

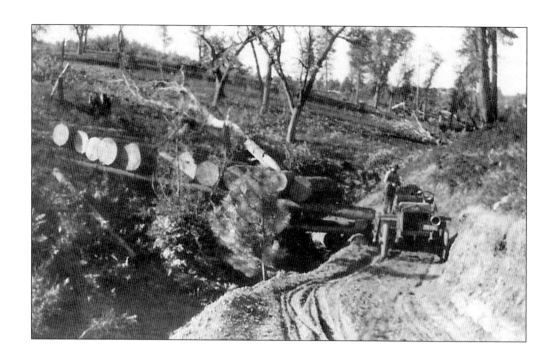

The log skidway above was constructed across a small drainage on the Howard Ranch near West Point in 1920. Most of the pine had been felled and bucked into 16-foot, 6-inch lengths. The other varieties of trees had for the most part been left standing. Below is a close-up of the log skidway showing how it was constructed using smaller-dimension pine poles. The height of the skid allowed for easy loading onto trucks. (Courtesy of Diane Aksland Adams.)

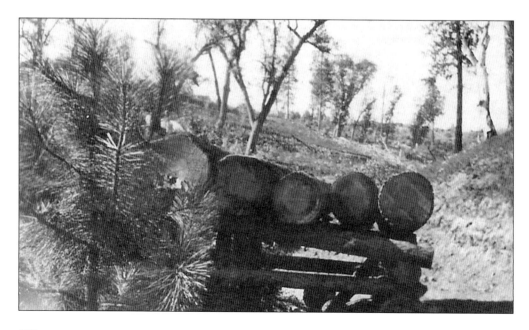

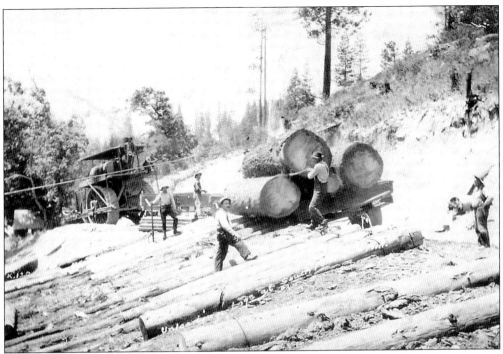
Here is Berry's mill near the South Fork of the Mokelumne River. A Holt steam traction engine pulled the log truck into position and is now being used to unload it with a winch cable. The road was built on a slant, allowing gravity to help in the process. One logger is using a pry bar to kick a log loose, which will roll down the log skidway onto a landing.

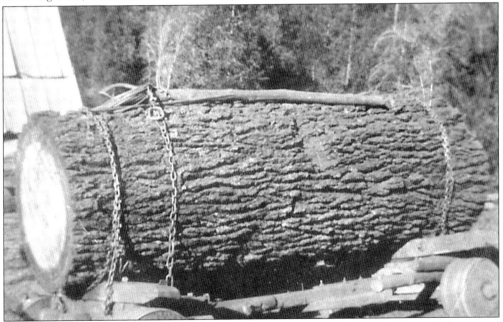
Pictured here is a first-growth sugar pine harvested in the early 1920s near Glencoe. The peavey hook chained to the log was used to turn bucked logs. The banded concrete wheels were common to log trucks of the day. (Courtesy Diane Aksland Adams.)

Because the West Point mill operated seasonally, the family could not effectively market their lumber during winter. It became apparent that the business needed to relocate to a lower elevation. In 1925, they signed a lease for land in Valley Springs, Calaveras County, and opened the Valley Spring Lumberyard. While her husband and sons continued operating the sawmill in West Point, Susan Berry ran the lumberyard (above). Rough-cut lumber was delivered to the Berry planing mill located behind the yard (below). There it was cut to dimension and finished. The two photographs on this page were taken in October 1930. (Courtesy Diane Aksland Adams.)

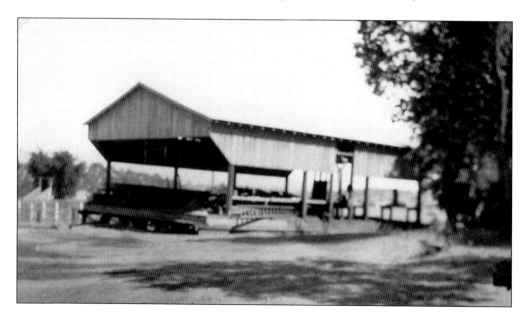

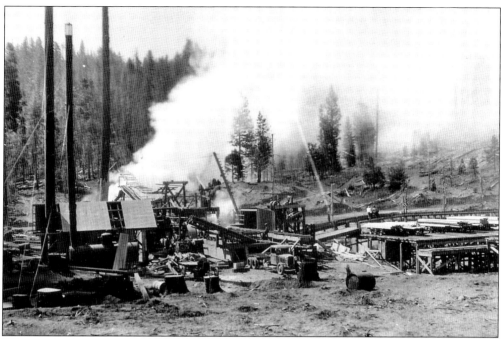

When timber became scarce in Calaveras County, the family looked elsewhere for another location. In 1929, they leased 160 acres from the George Allen estate at PiPi Valley, El Dorado County. The Bank of Amador County orchestrated this transaction to ease the Depression's effects on the region. The Allen family benefited financially, the Berry's need for timber was satisfied, Pacific Gas and Electric purchased lumber for the Mokelumne River flume, and the demand of the local mines for Douglas fir was fulfilled. By spring, the Berrys had a 30,000-board-foot steam-powered mill in operation. The elevated platform on the right is the green chain carrying rough-cut lumber from the mill to the sorting deck. Below Ben and Clarence Berry; Mr. Blomquist, the bookkeeper; and Pearl Wright are shown here in front of the new office.

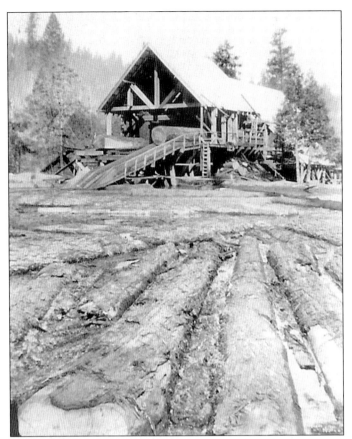

The C. A. Berry Sawmill was located on Sopiago Creek, which provided the water necessary to run the mill. The pond, created by damming Sopiago, could float 650,000 lineal feet of logs. At left, a log has been winched up the jack ladder from the pond and now sits upon the log deck. A second log, resting on the carriage, has already had one side slabbed off. Once the wood had been cut into its final dimensions, it was started down the green chain to be sorted by size. The below photograph is of the Berry Lumber Company green chain. Men stood on the walkway next to the green chain. As the lumber rode by, the men pulled the individual cuts over the rail and placed them into the appropriate stacks of sized limber.

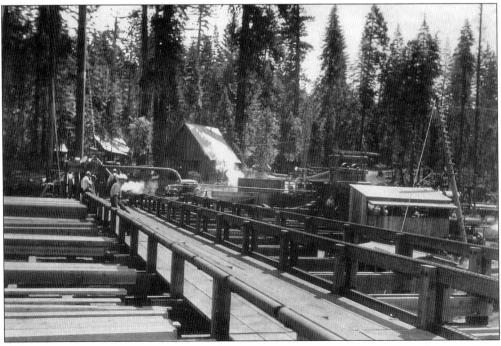

As the sawmill grew, Clarence and his sons could not handle its operation alone. They were forced to hire additional loggers, especially during periods of high production. At right are longtime employees Johnnie Drendel (left) and Nerts Howe (right). By 1933, the company had about 30 employees and had contracted to mill two million board feet. Over the next decade, the company employed 30 to 50 men, supplied much of the county's lumber, and was a major player in Amador County's economy. Pictured below are, from left to right, Roy Harrison, Frank Berry, Frances Rose, Forest Rose, Bruce O'Neal, and Cecil Harrison.

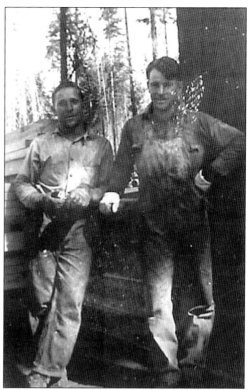

Working in the woods was a dangerous occupation, often resulting in accidents and sometimes death. William Fairchild, pictured above at age 21, was the brother of Susan Fairchild Berry. He was born in South Dakota in 1882 and moved with his family to Glencoe, Calaveras County, at age three. As a longtime employee of the Berry Lumber Company, Fairchild had worked as a faller for many years. The *Amador Dispatch* reported his death on June 23, 1933. William Fairchild was killed "when he was struck by a falling tree [while] operating a gas engine propelled dragsaw." The noise had prevented him from hearing "the crash of falling timber or the shouts of his companions."

W. Fairchilds Killed by Tree

William Fairchilds was instantly killed last Saturday afternoon about two o'clock when he was struck by a falling tree at the site of the C. A. Berry and Sons sawmill near Cooks station. Mr. Fairchilds was engaged in operating a dragsaw propelled by a gasoline engine when the accident occurred and the noise of the machine prevented his hearing the crash of the falling timber as well as the warning that his companions endeavored to convey to him before he was struck. His head and the lower portion of his body was crushed by the impact of the tree.

Deceased was a native of South Dakota aged 51 years. For many years he had resided in Calaveras and Amador counties and had been an employee of the Berry Lumber Yard for a long time.

His funeral was held in this city on Tuesday afternoon being from the mortuary chapel of J. J. Daneri and Son thence to Railroad Flat, Calaveras county where interment took place. Services were conducted by Rev. Upton E. Partirdge of this city.

Immediate relatives include a widow, Louise Fairchilds, of Valley Springs, and three sisters, Mrs. C. A. Berry of Valley Springs, Mrs. Turner Lillie of Angels Camp, and Mrs. Markwood of Paloma.

BERRY SAWMILL WAS DESTROYED

The plant of the big sawmill of C. A. Berry and Sons in the Pioneer district was destroyed on Monday evening about five o'clock by a fire of undetermined origin. When discovered the planning mill was a mass of flames and in spite of every effort of the crew of men engaged at the property the flames spread rapidly to destroy the mill and a number of other buildings on the property. Effective work by the fire fighters saved about one and one-half million feet of lumber that was stored in the yards.

The mill had been operated for several years past by the Berry's and was providing employment for a crew of forty-seven men when destroyed by fire. Recently an appeal had been made to the federal government for an additional allotment of timber that sawing might be continued during the forthcoming summer months. This appeal was meeting with favorable consideration at the time of the fire. It was located a short distance from the Jackson-Alpine highway near Ham station in a heavily timbered section that has provided timber for cutting for several years operation. The loss is estimated at approximately $50,000 and comes as a severe blow to the owners as will as this entire community where it afforded an appreciable payroll.

During the fire Earl Berry, one of the owners of the plant, was severely burned upon the hands while engaged in fire fighting. He was brought to this city where he was given medical attention.

Disaster again struck in August 1934, when the C. A. Berry Sawmill was partially destroyed by fire. Most likely started by a negligently tossed cigarette, the fire incinerated the sawmill, planing mill, and several outbuildings. The company's 47 employees were able save about 1.5 million feet of lumber stored in the yard. Earl Berry's hands, however, were severely burned while fighting the fire. The estimated loss totaled over $50,000. Once again, the Bank of Amador County came to the aid of the family, loaning them money to rebuild. The family partnership of father and sons was converted to a corporation, the Berry Lumber Company, and the mill property was purchased from the Allen estate. By 1935, the mill was again in full operation. Below is one of the first stock certificates issued by the corporation.

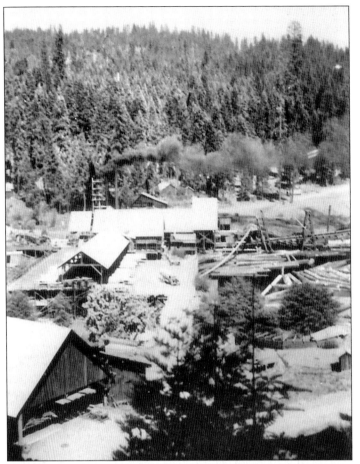

Pictured at left is the newly rebuilt Berry Lumber Company. The 1930s and 1940s were a time of great expansion and change in the timber industry. Prior to World War II, over 16 million board feet of lumber was delivered to the mines per year. During the war, production and employment at the company soared to all-time highs. But peak production was actually reached during the post–World War II years. By that time, the company employed up to 120 men. After the war and the closing of the mines, the demand for lumber was for domestic housing. Pictured below is the planing mill with the largest cut for the year 1942.

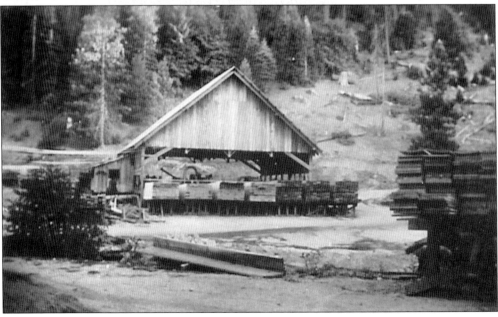

Despite the mill's success after its move to PiPi Valley, winter still effectively closed its operation each year. The Berry Lumber Company opened a second lumberyard and planing mill in Pine Grove, which was a good 1,000 feet lower in elevation. The yard was located along Berry Street and at the site of the present-day ACES Waste Disposal.

The below aerial view of the Berry Lumber Company, taken in 1942, shows the mill, ponds, and log and lumberyards. As there was no electricity in the area, two generators, one diesel and another steam, powered the assorted electric motors needed to run the mill. By the mid-1940s, Wetsel Oviatt and the Winton Lumber Companies had began operations, providing real competition for the company.

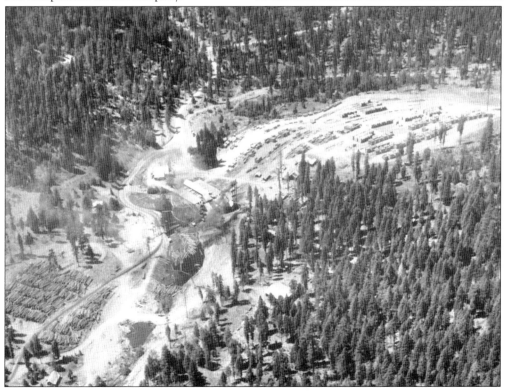

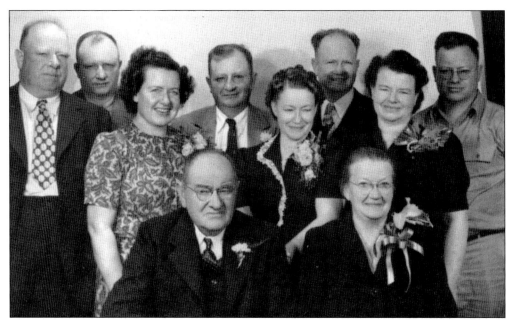

The above photograph was taken on January 27, 1945, during Clarence and Susan's 50th wedding anniversary. From left to right are (first row) Clarence and Susan Fairchild Berry; (second row) Esther, Elizabeth, and Ruth; (third row) Earl, Frank, George, Ben, and Ted. Each of the Berry brothers had a specific job. Earl was the sawyer at the mill, sharpening and balancing saws. Although a high rigger in earlier years, Frank later became the company's chief salesman. George had charge of the sawmill, Ben was the mechanic, and Ted the mill's general repairman. By this time, Clarence had retired. He died the following year on November 21, 1946. Below, Berry Lumber Company employee Pete Dahl examines the "butt end" of a felled sugar pine showing the undercut made by the fallers.

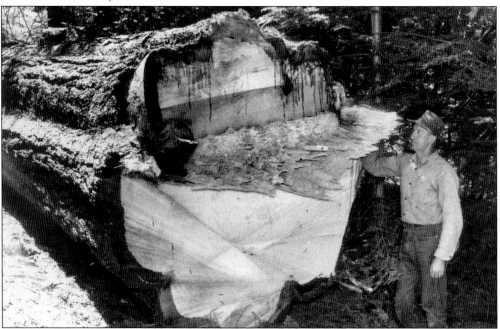

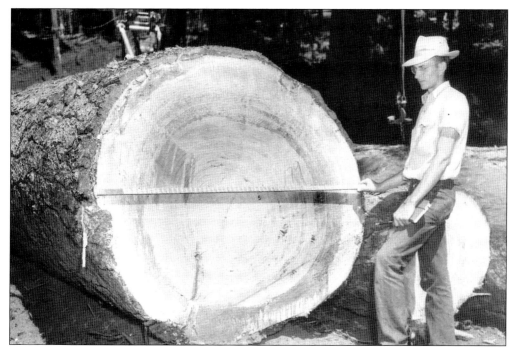

This felled pine is being scaled by an employee of the U.S. Forest Service. By measuring, the scaler was able to accurately determine the board feet of lumber that would be produced from any particular tree.

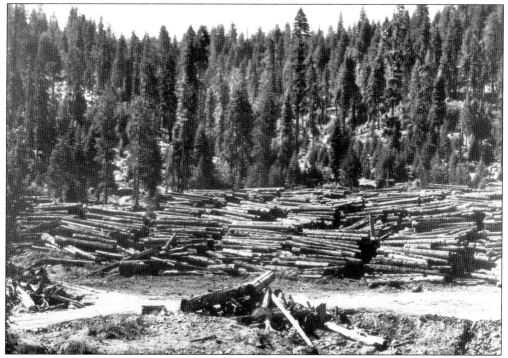

When timber was delivered to the Berry Lumber Mill, some logs were stored on a log deck located near the pond. They would later be transferred into the pond shortly before milling.

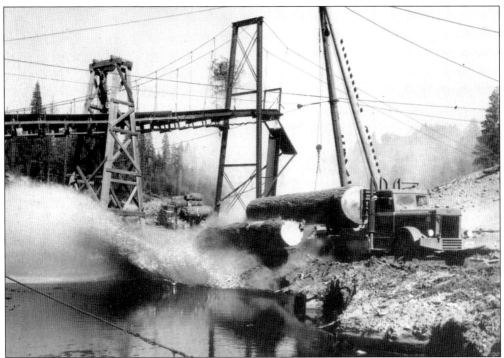

Other deliveries were dumped directly into the pond. Pictured here, an A-frame crane lifts logs off truck. In the background, another truck awaits unloading.

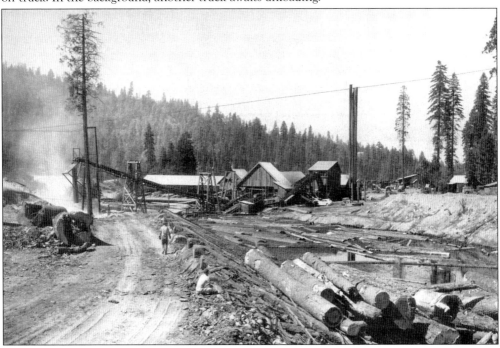

In this view of the log pond, the slab chain is easily seen. The chain hauls slash wood and sawdust from the mill and dumps it into the slash pile, where it is burned. All of the equipment in this mill is steam powered using waste as fuel.

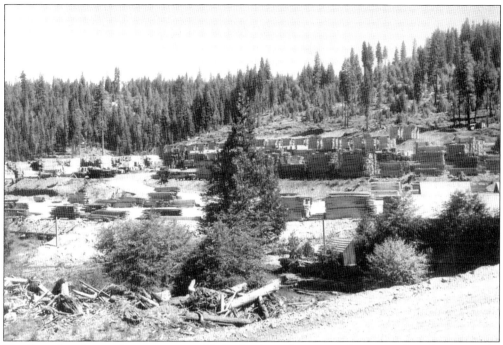

The Berry Lumber yard sat on a terraced hillside where the various dimensional-cut lumber stacks were stored for drying and shipping.

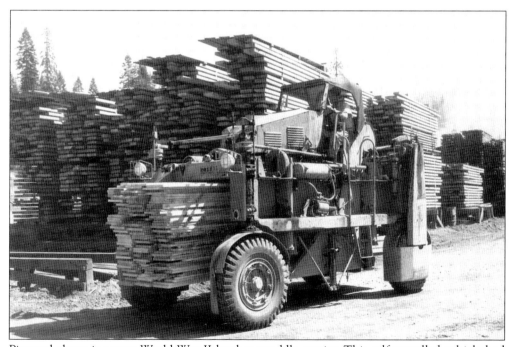

Pictured above is a post–World War II lumber straddle carrier. This self-propelled vehicle had a chassis far above the ground so that loads of lumber could be hauled beneath the chassis and between the wheels.

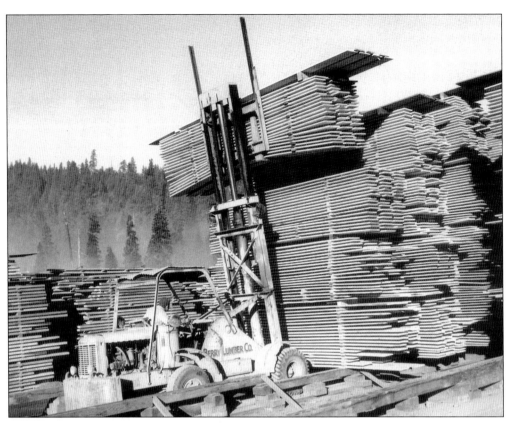

Above is an early forklift moving units of rough-cut lumber into stacks, which have been stickered off for uniform drying with minimum warping. Below, a shipment of lumber is being loaded on a truck and trailer. The forklift, developed in the 1920s, was used to lift and transport materials by means of steel forks inserted under the load. It became an indispensable piece of equipment in the lumber industry.

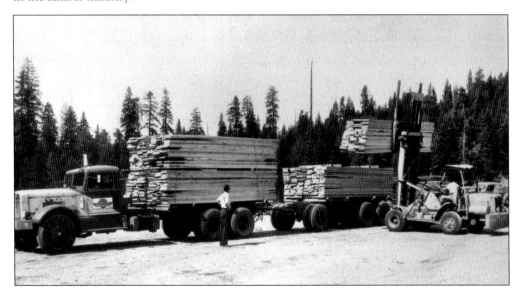

By the late 1950s, most privately owned property had been harvested. The only timber available was on U.S. Forest Service land, and government contracts had become more difficult to obtain. According to Ben Berry, "All you had to do was lose a bid and you were done—sitting there with all your overhead and nothing to do." Pictured above are, from left to right, George Allen, Ben Berry, and George Berry during an impromptu meeting.

The mill had originally been set up to process large timber. However, only small-diameter logs remained. Ben said, "Our circular saws cut too big a kerf" compared to the modern band saw. With the increasing cost of timber, the company became too costly to operate. Pictured here is a typical second-growth timber stand.

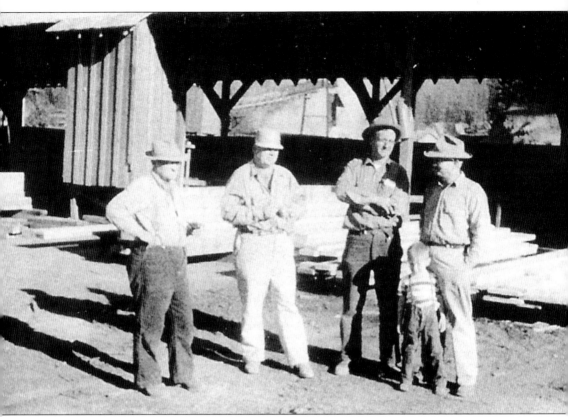

After operating for almost 50 years, the Berry Lumber Company closed down. All equipment and property was sold during an auction held in May 1960. Ben would later claim that the dwindling timber supply, the band saw, and the U.S. Forest Service bidding process spelled the end of the logging camp. Or maybe "we were simply getting too old to cope with it." Later that year, a recession hit and the bottom dropped out of the lumber market. "Talk about good timing!," Ben said. Pictured here from left to right are George and Frank Berry, Roy Harrison, Ben Berry, and Ben's son, John, standing near the mill in 1956.

BIBLIOGRAPHY

Alpine County Historical Society. *Alpine County, Bear Valley, Kirkwood, and Markleeville.* San Francisco, CA: Arcadia Publishing, 2005.
Andrews, Ralph W. *This was Logging.* Atglen, PA: Schiffer Publishing, 1984.
———. *This was Sawmilling: Sawdust Sagas of the Western Mills.* Atglen, PA: Schiffer Publishing, 1994.
———. *Timber, Toil and Trouble in the Big Woods.* Atglen, PA: Schiffer Publishing, 1984.
Beesley, David. *Past Sierra Nevada Landscapes.* Reconstructing the Landscape: An Environmental History, 1820–1960. Berkeley, California: 1996.
Bryant, Ralph Clement, *Logging: The Principles and General Methods of Operation in the United States.* New York: John Wiley and Sons, 1913.
Davis, Richard A., ed. *Encyclopedia of American Forest and Conservation History.* Vols. 1 and 2. New York: Macmillan, 1983.
Gruell, George E. *Fire in Sierra Nevada Forests, A Photographic Interpretation of Ecological Change Since 1849.* Missoula, MT: Mountain Press, 2001.
Mason, J. D. *History of Amador County, California.* Oakland, CA: Thompson and West, 1881.
The Centennial Book Committee. *One Hundred Years of History, Recreation, Lore in Alpine County, California 1864–1964*, rev. ed. , 1987.

Across America, People are Discovering Something Wonderful. Their Heritage.

Arcadia Publishing is the leading local history publisher in the United States. With more than 4,000 titles in print and hundreds of new titles released every year, Arcadia has extensive specialized experience chronicling the history of communities and celebrating America's hidden stories, bringing to life the people, places, and events from the past. To discover the history of other communities across the nation, please visit:

www.arcadiapublishing.com

Customized search tools allow you to find regional history books about the town where you grew up, the cities where your friends and family live, the town where your parents met, or even that retirement spot you've been dreaming about.